Peter
Evers

Wicklow
Photographs

Huxley
Press

For
Susie

'On a calm day in the mountains, I postponed all purpose
and allowed my spirit to be still. When I was as calm as the lake was
I mirrored the mountains  serenely as it did. Mirroring them,
I didn't modify them. No ebbing into self awareness shimmered them.
Clear, like the lake, to my very depths, they touched the quick in me
with their unperturbed, ageless summits. By nightfall there was no me....
All of this wasn't something I did. All of this, when I surrendered to them,
was something my surroundings did for me. It was with my surroundings
that I walked into myself and found eternity.'

John Moriarty

The geography of our imaginations is curiously resistant to change. Within the asphalt city, many people dream of an elsewhere which will strip them of their daily lives, and extend to them a landscape where their unencumbered selves can stretch to full capacity in the rarefied air. High above Tintern Abbey, looking down on the 'wild secluded scene', Wordsworth found himself 'well-pleased to recognize / In nature and the language of the sense, / The anchor of my purest thoughts.' Yosemite National Park and the Arizona deserts provided the Californian photographer, Ansel Adams, with the dramas of light and rock he needed to explore how these wildernesses might, in their vast and pristine nature, come to serve as religious ideas in and of themselves.

As these examples attest, for the natural world to be perceived as landscape it must be framed first in the imagination, where it is shaped by individual memory and desire. This remains the case, even when, as John Moriarty suggests, the observer most wishes his individuality to be annihilated in the majesty of the experience. By choosing lenses that most mimic the range of the human eye, Peter Evers performs the paradox of evaporating into the view through the camera's lens. He calls attention to the quietness of his vantage point and his own 'language of the sense', just as he withdraws from it.

It will surprise some readers of this book to find that Evers has discovered his sublime, not in the mythic 'West' of Ireland, but in the glens of Wicklow on the East coast. His moonlit photographs of 'The Coronation Plantation' at the Sally Gap, achieved with a four minute exposure, suggest a primordial light far removed from the glare of Dublin city that lies a mere sixteen miles away to the north-east. In the pools of the Cloghoge and Avonmore Rivers, he discovers the swirl of nebulae as water briefly becomes another element entirely, tar perhaps on its way to becoming rock. As deer pick their way across the quartz-covered scree of a deserted miner's village, the migration patterns of vaster herds momentarily come to mind, making Wicklow seem as indomitable a country as any nineteenth-century frontier.

Yet as depopulated as these landscapes are, in many of these photographs there are signs of prior excursions by other frontiersmen. The yellow rushes at Inchavore are divided by a rough path; the Glenealo Falls descend through Coillte plantations towards a distant lake. Gorse and foxgloves colonise the rough ground after conifers have been clear-felled for commercial use. If, in this sense of renewal, nature offers us consolation for our mortality, the twisted and lichen-covered branches in these pictures are not just living sculptures, but *memento mori*, and the piebald ponies and white muzzled donkeys, clowns in a *danse macabre*. The mobile homes of an abandoned holiday camp at Bonagrew fit in here as reminders that all memories are fragile, apt to decay into fragments as quickly weathered as the net curtains and aluminium frames flittering in the wind. Technically, this sense of mortality is embodied in Evers' decision to use discontinued film stock for some of these shots (Kodak 160T for 'Fireweed at Rathnew') and in the lith-prints, which demand the photographer wait until he sees the unique image emerge out of its own shadows in the darkroom's trays. This patience is rewarded in the beauty of 'Beneath Sheepbanks towards Lough Tay' and 'Wild Garlic at Avondale,' where every frond of vegetation seems precisely textured and delineated against the overall composition.

Only when a photographer has sufficiently mastered the techniques of his craft to surrender quietly to the image, can a landscape emerge as gloriously sublime as Wicklow appears here. Any traveller can marvel at this county's great bounty, but only the exceptional can bring its beauty home in their descriptions. Like the playwright, J.M. Synge, Peter Evers has made the Wicklow landscape into the kind of wild and credible elsewhere that might serve as the anchor for our purest thoughts, securing us with its beauty through the storms of daily life.

Selina Guinness

01
Inchavore

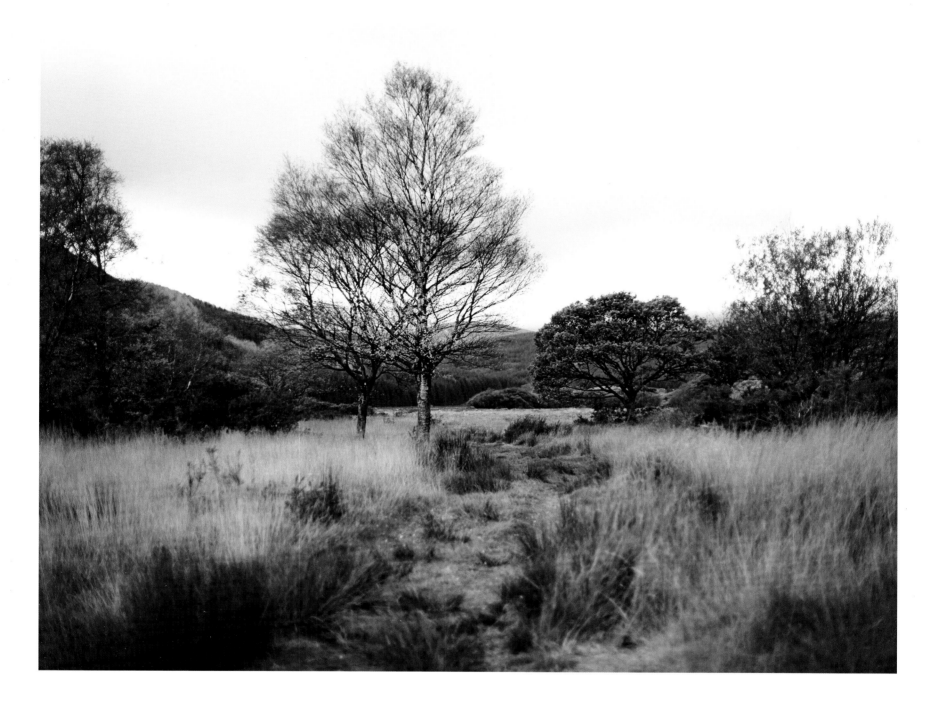

02
Scree
Knocknacloghoge

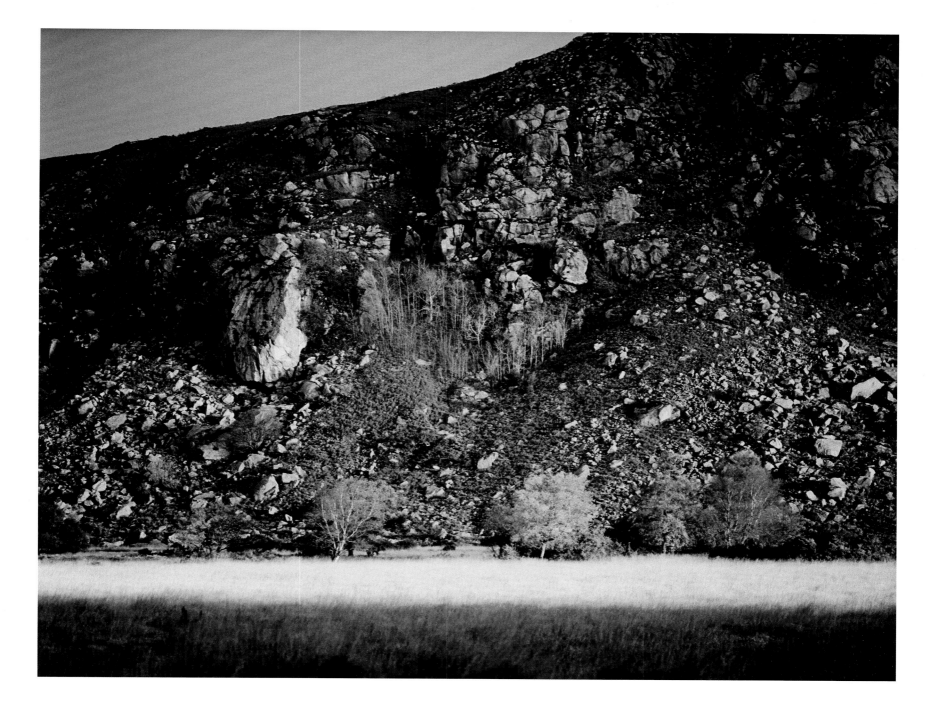

03
Alders
Lough Dan

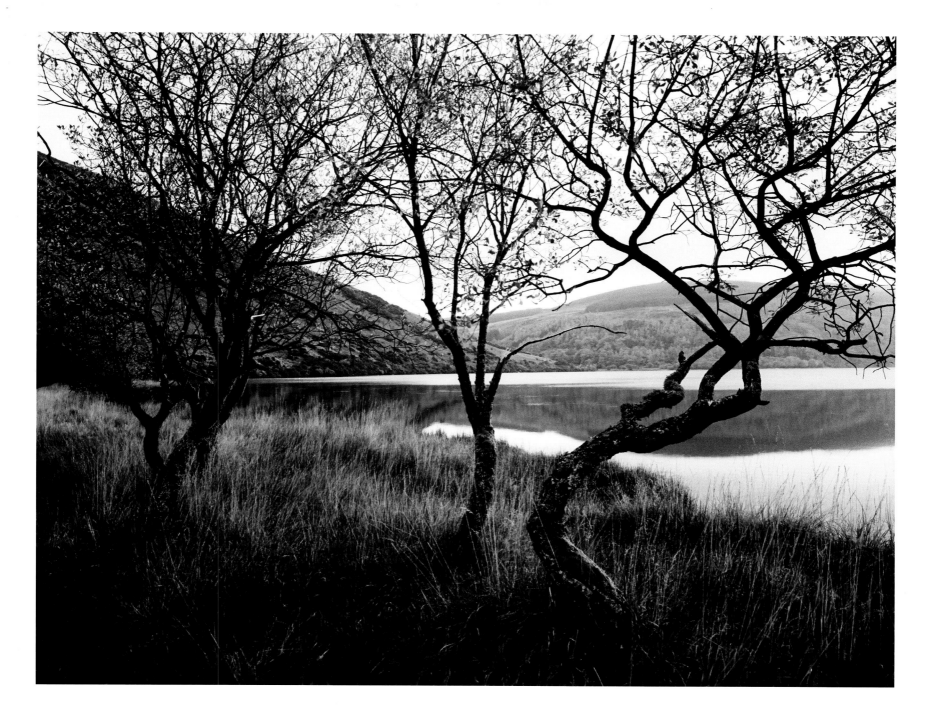

04
Piebald horses
Annamoe

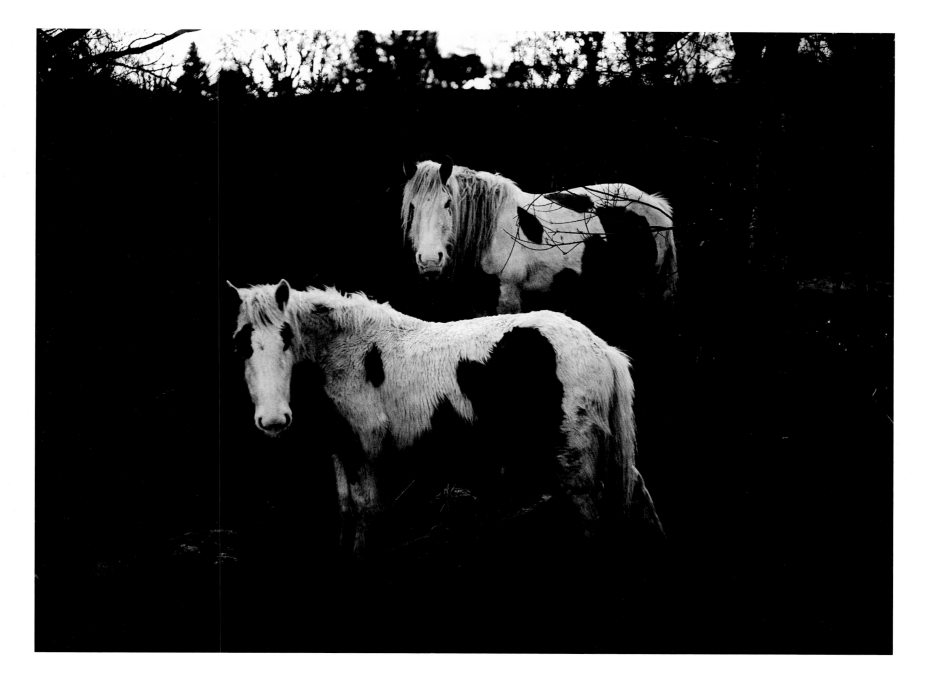

05
Piebald horses
Annamoe

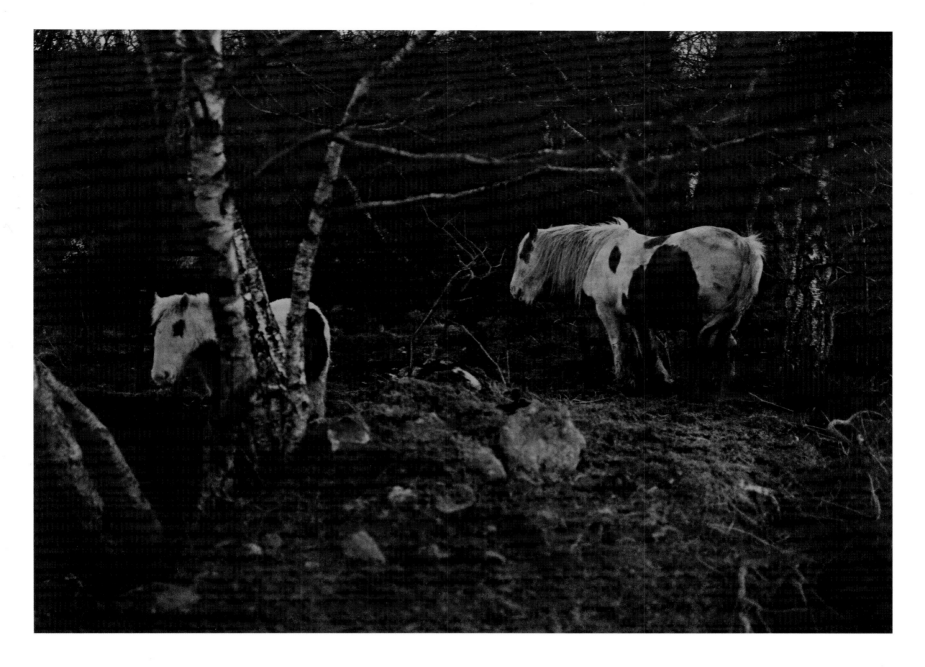

06
Stone track by Moonlight
Coronation Plantation

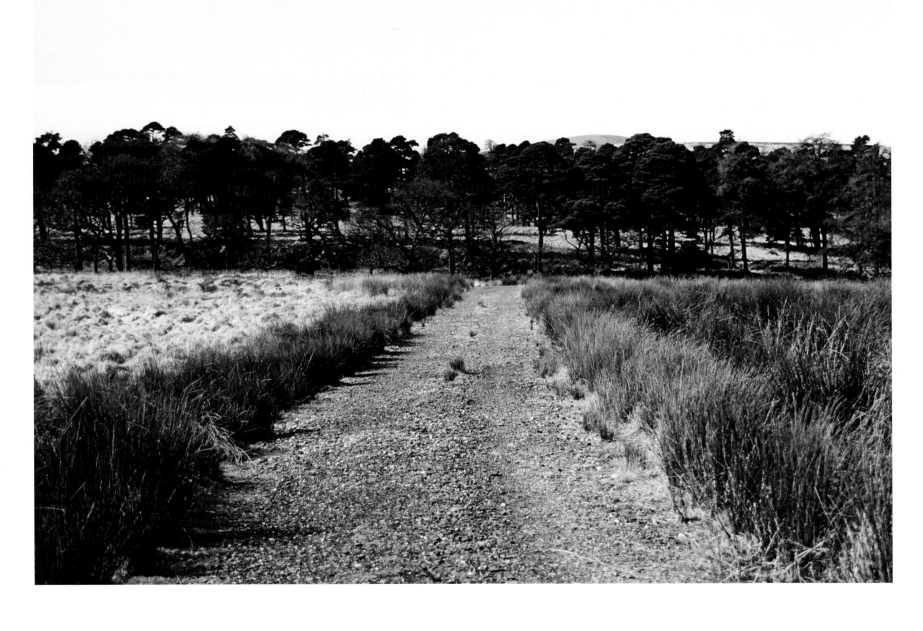

07
Scots Pines by Moonlight
Coronation Plantation

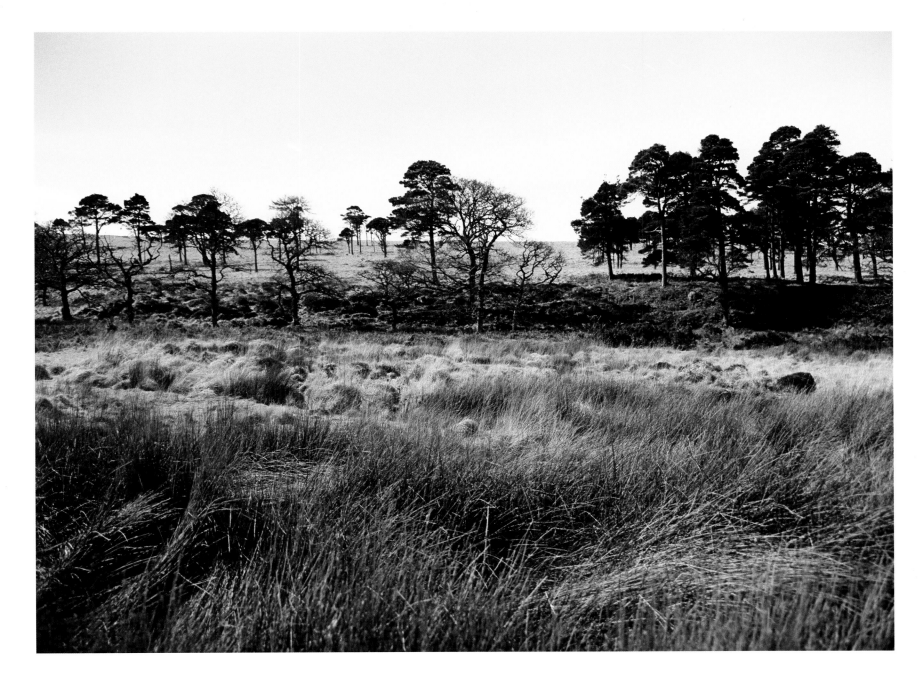

08
River Liffey by Moonlight
Coronation Plantation

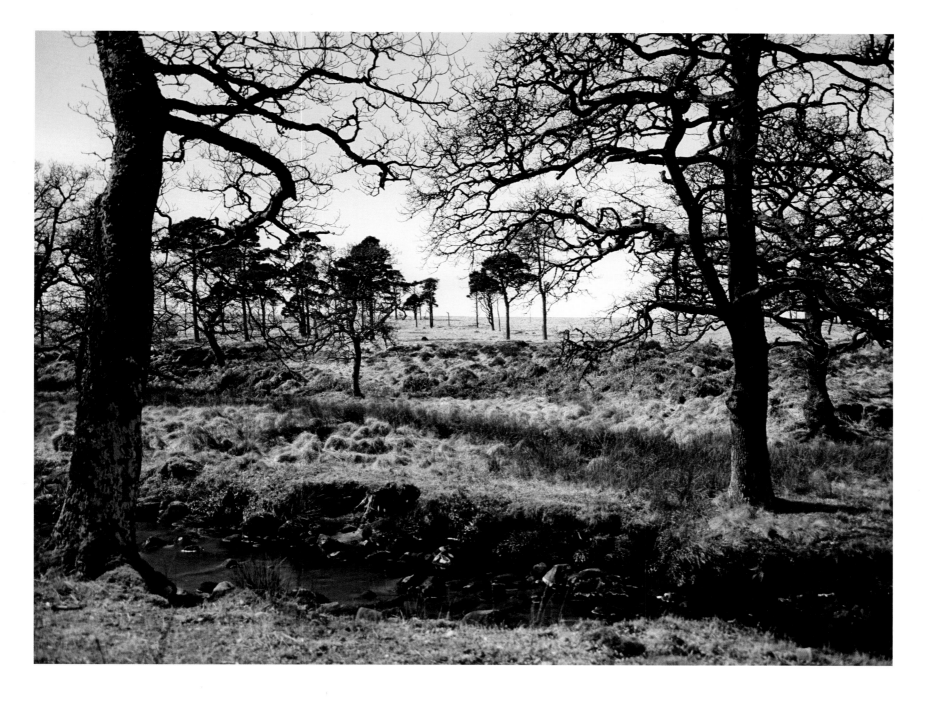

09
Summer leaves
Lugalla

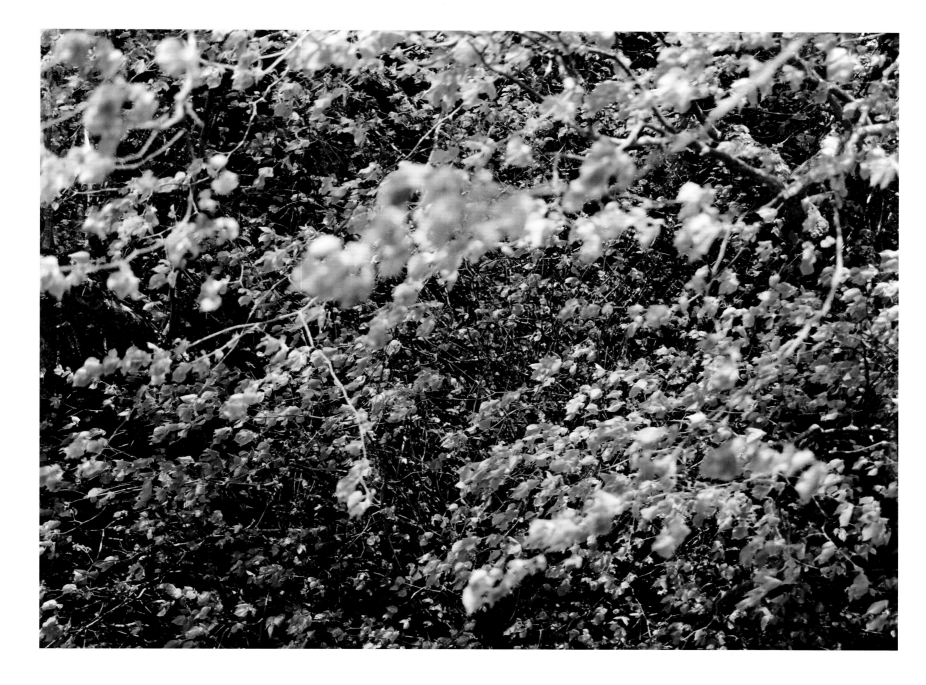

10
Cloghoge river
Fancy Mountain

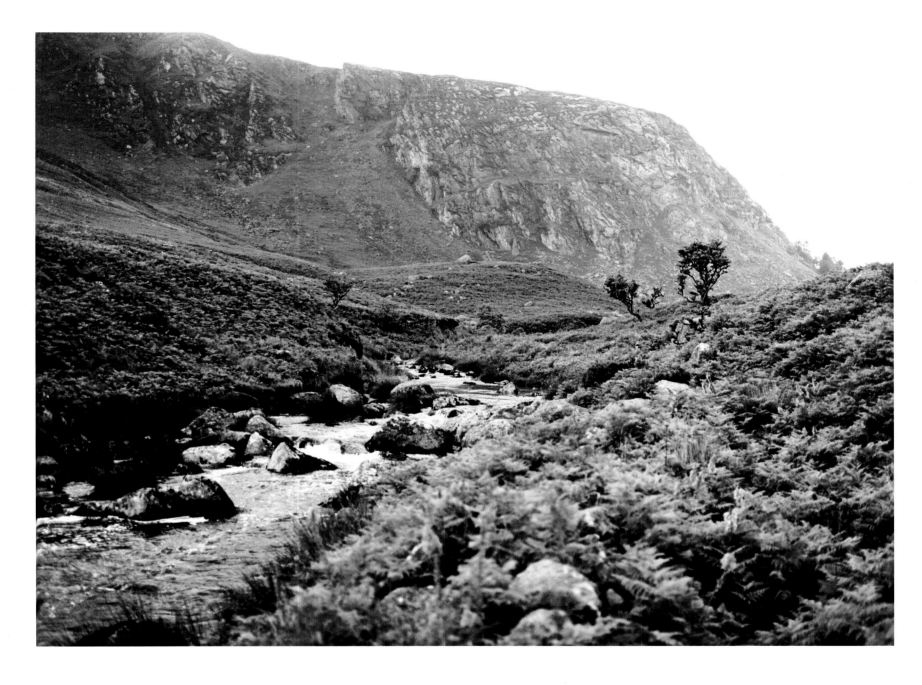

10
Ferns
Fancy Mountain

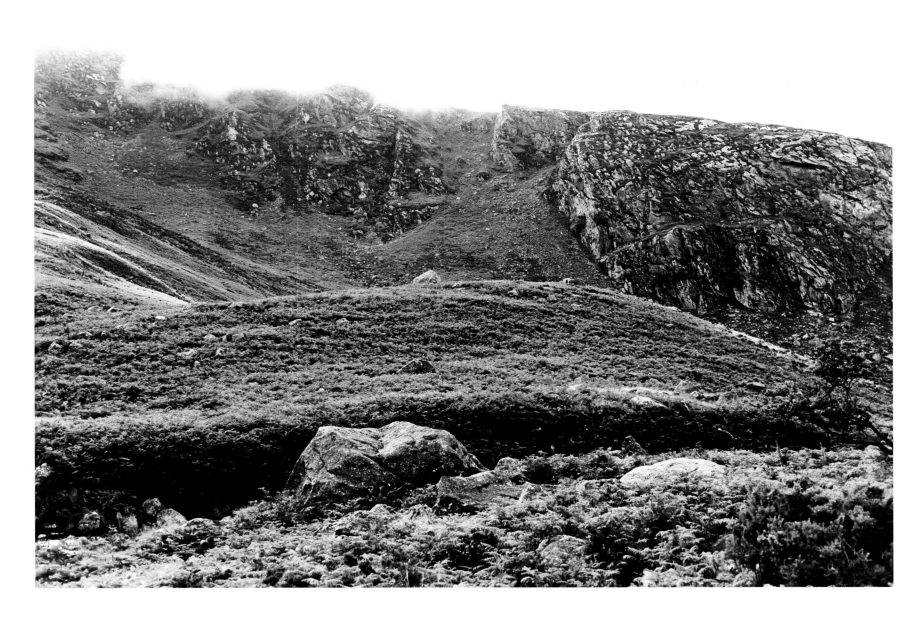

11
Wary deer
Ballinrush Woods

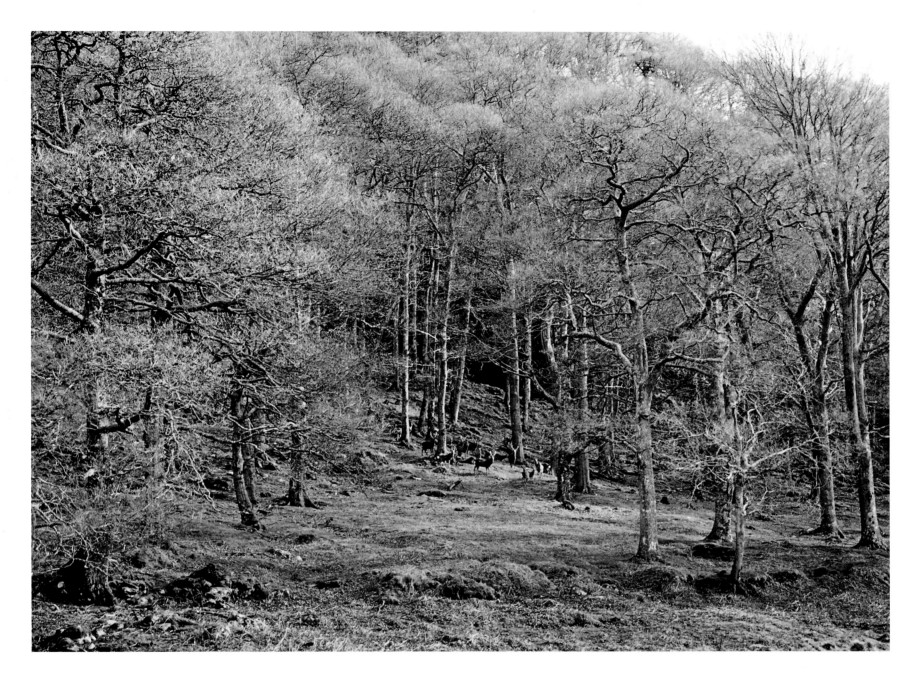

12
Rocks
Ballynacarraig

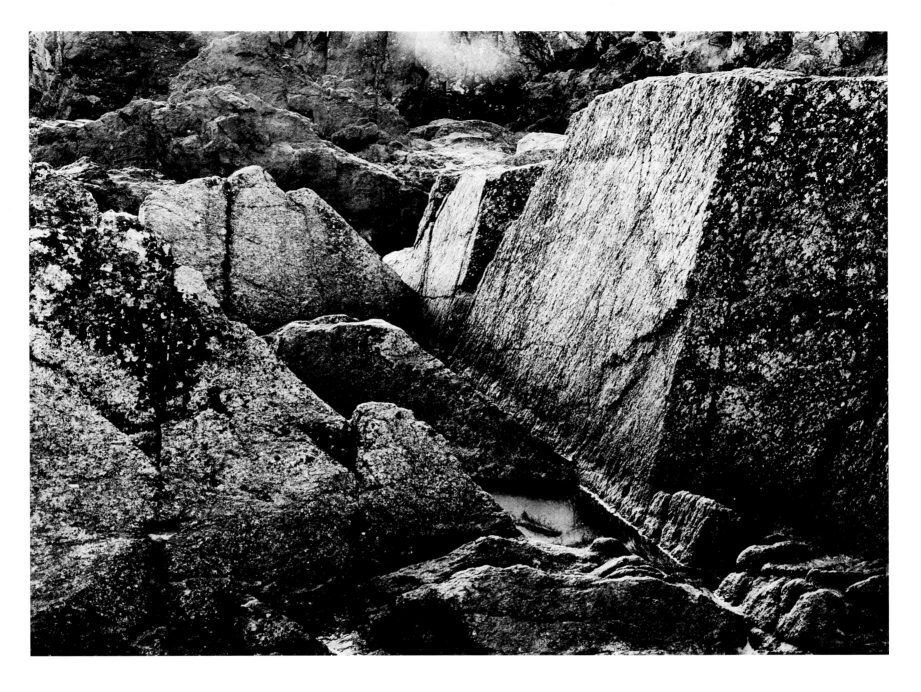

13
Rock
Brittas Bay

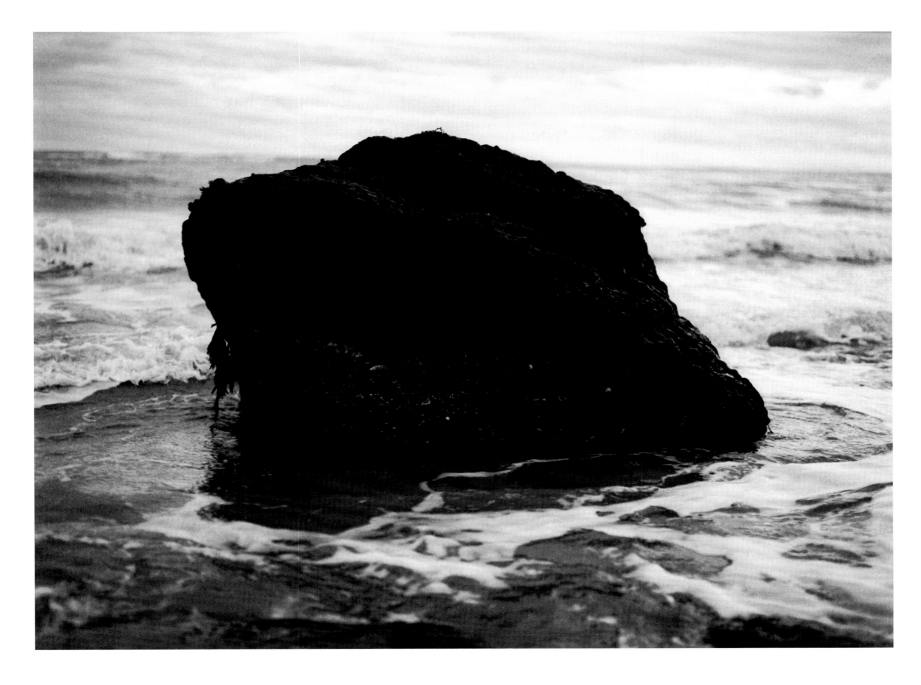

15
Water's edge
Brittas Bay

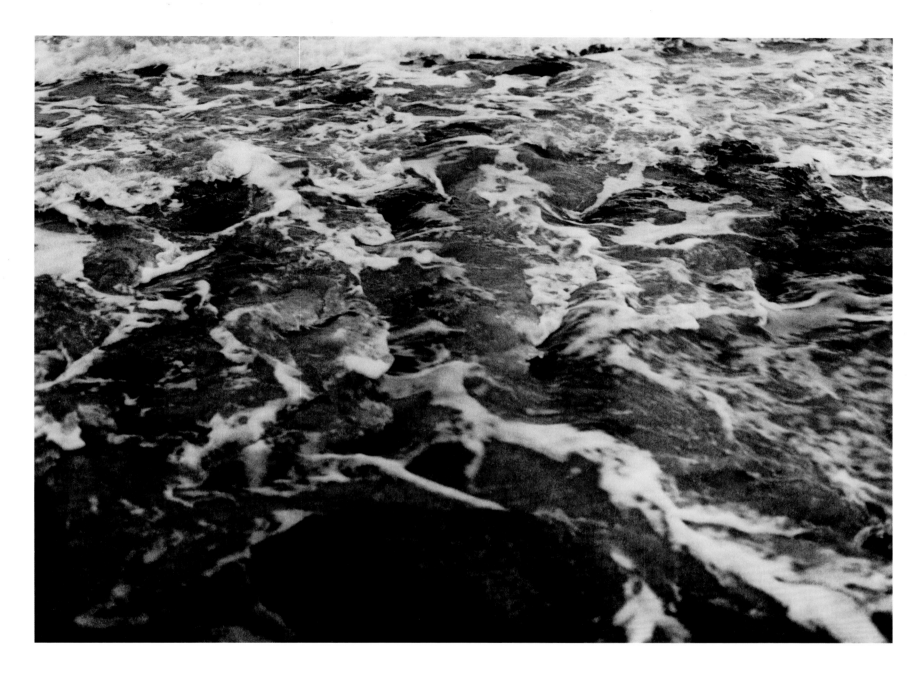

16
Pool
Ballynacarraig

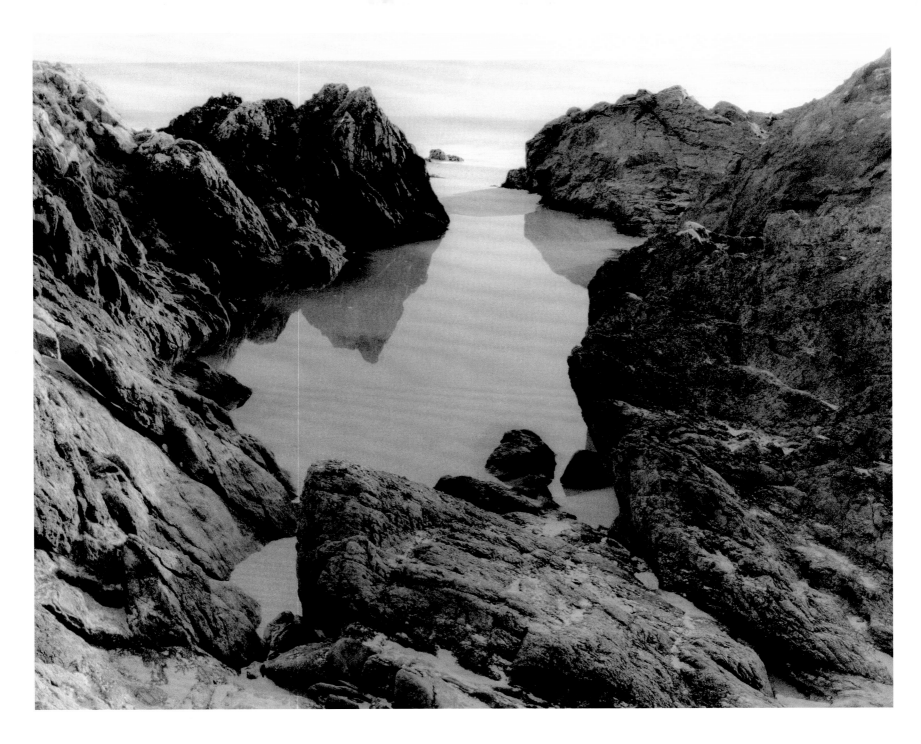

17
Shallows
Lower Lake
Glendalough

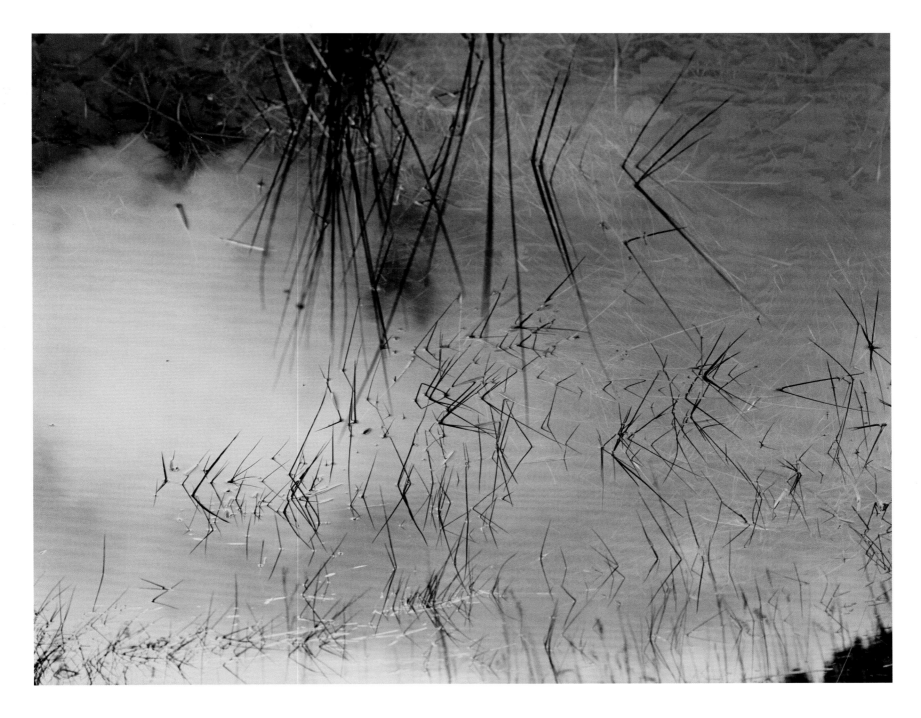

18
Swans
Bray Harbour

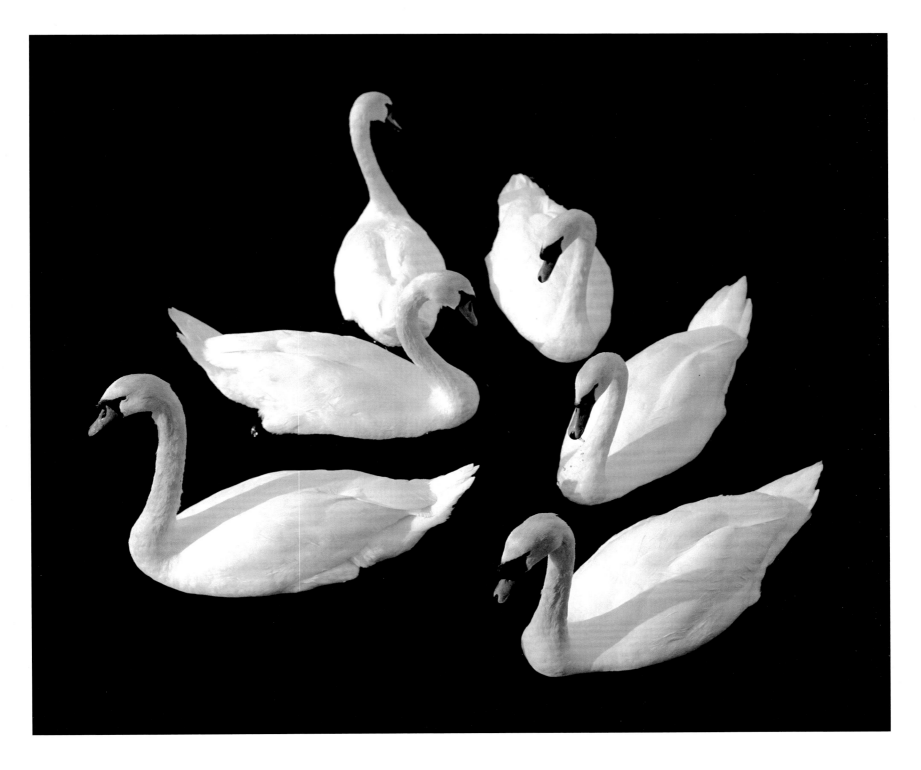

19
Swan
Bray Harbour

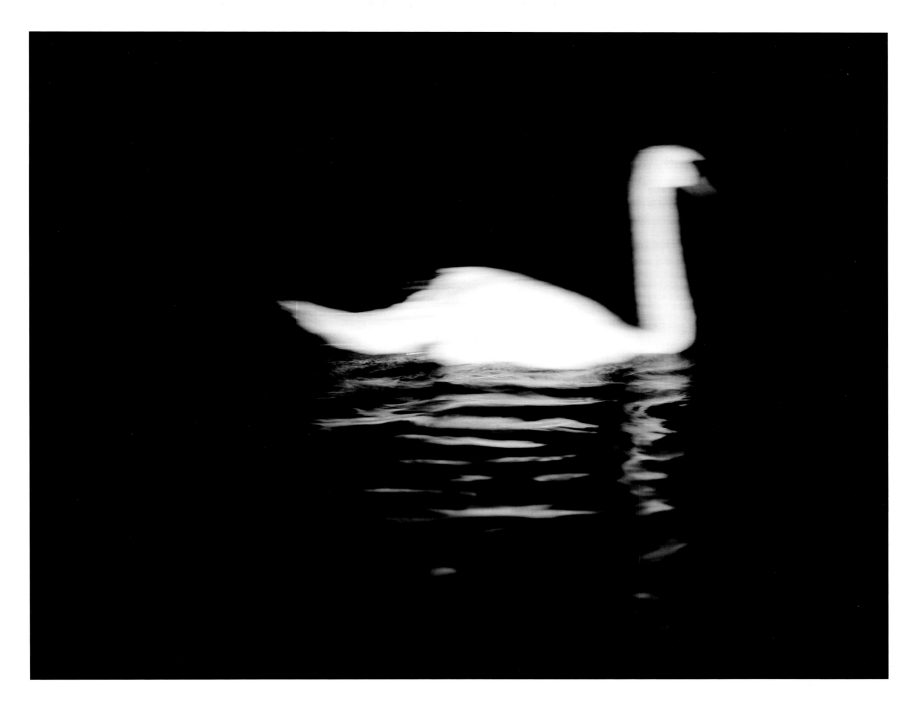

20
Swans
Bray Harbour

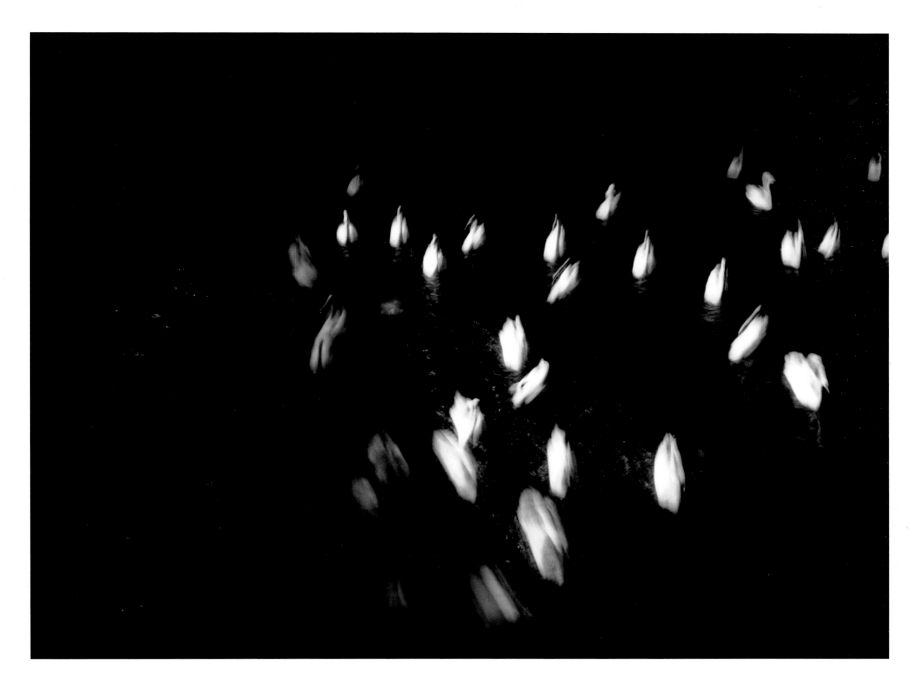

21
Swans
Bray Harbour

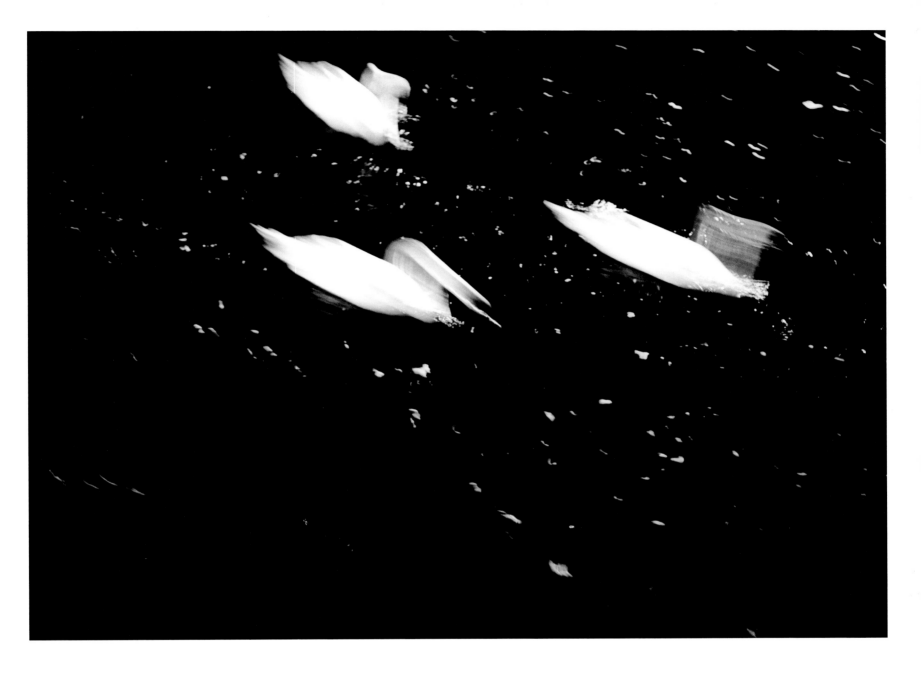

22
Swans
Bray Harbour

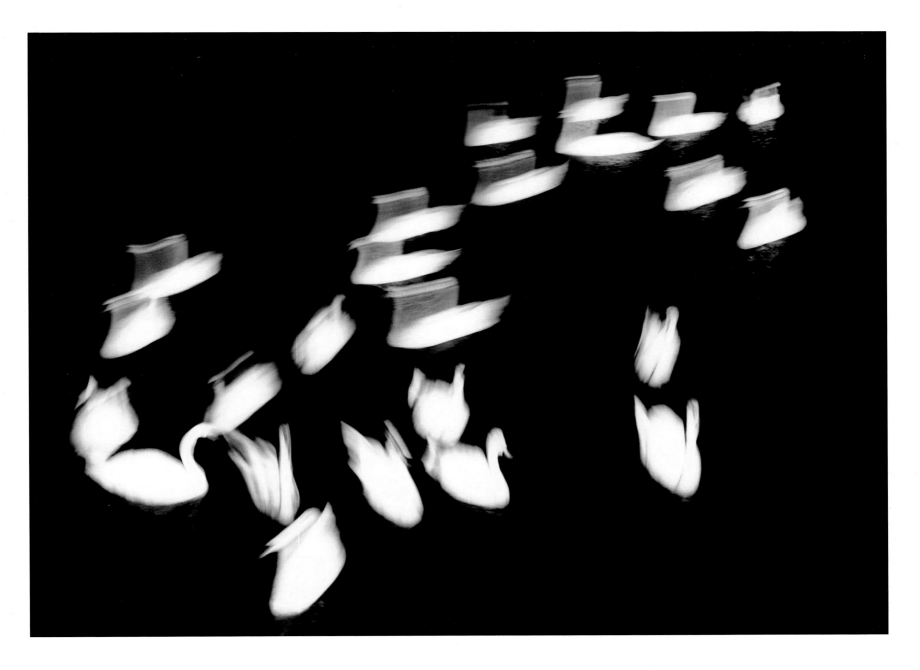

23
Swans
Bray Harbour

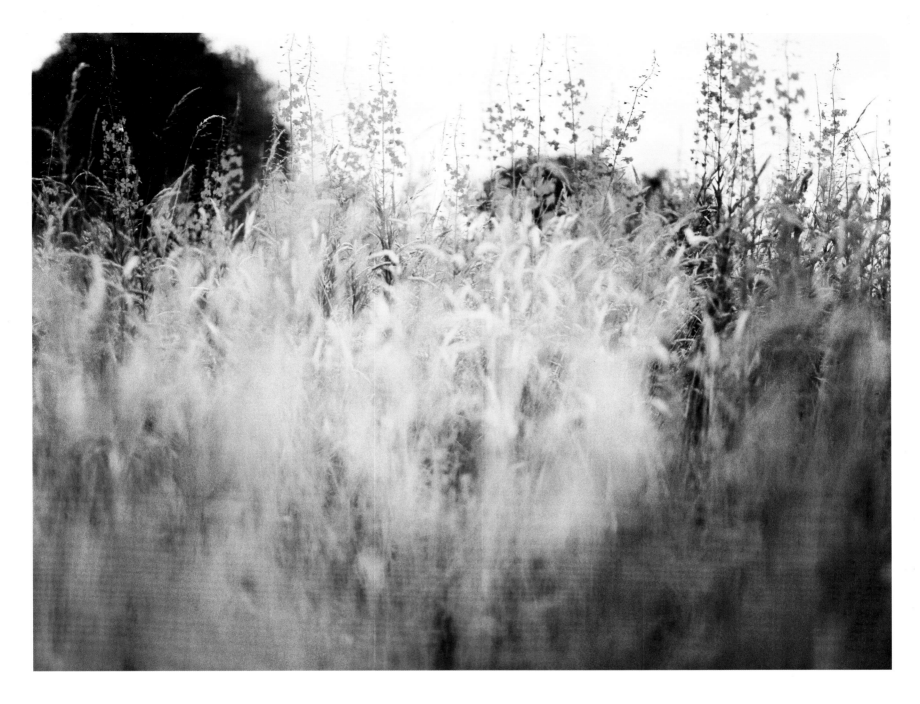

25
Fireweed
Rathnew

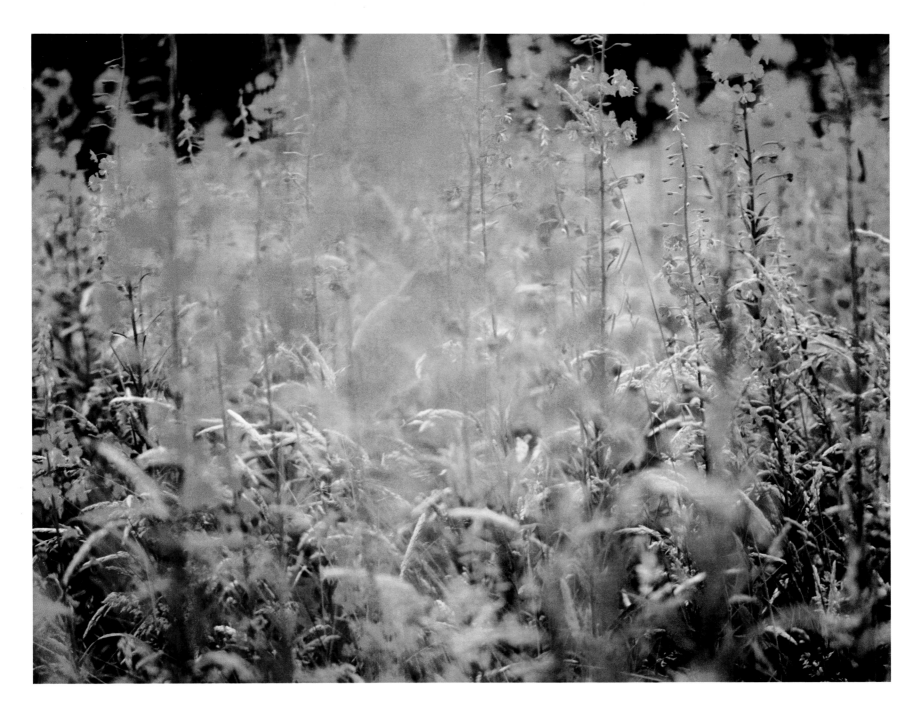

26
Foxgloves on Scarr
towards Glenmacnass

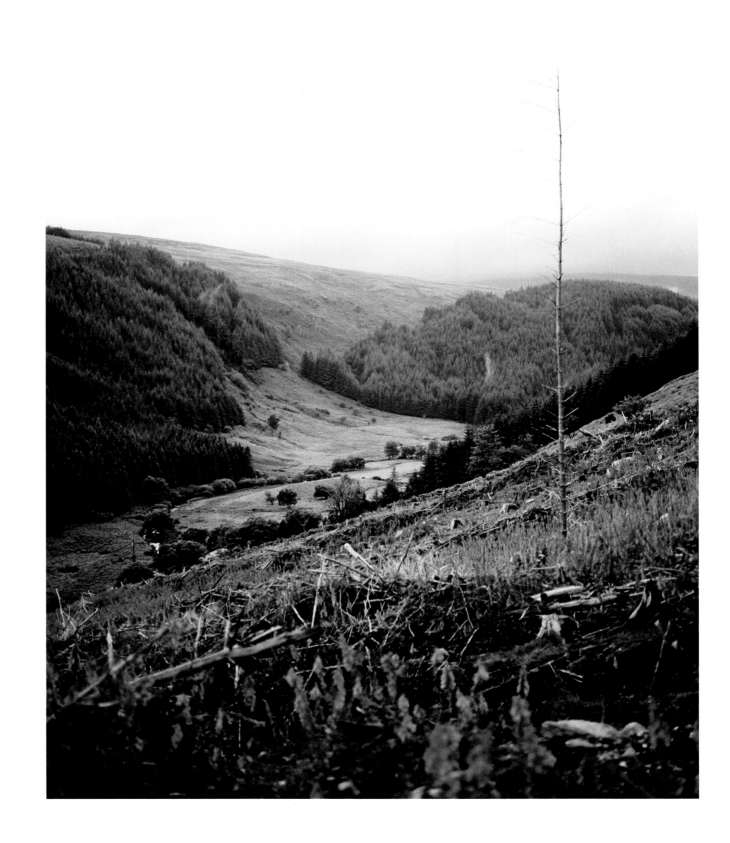

27
Heather and Fog
Sallygap

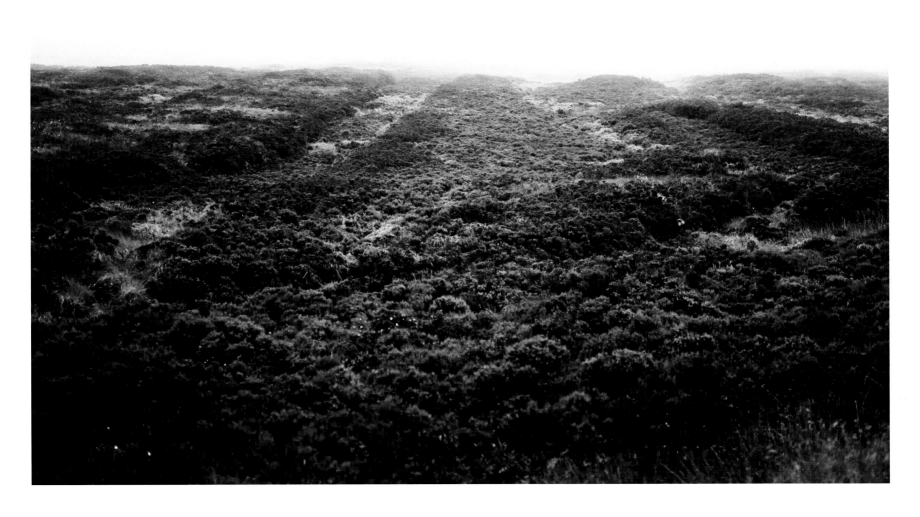

28
Lough Tay

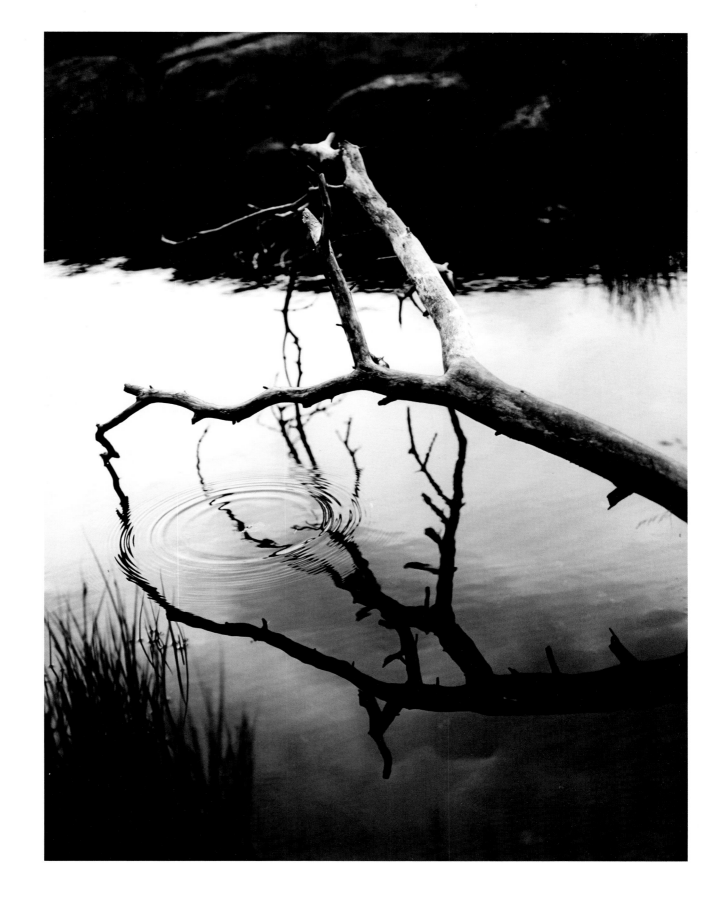

29
Cloghoge Valley

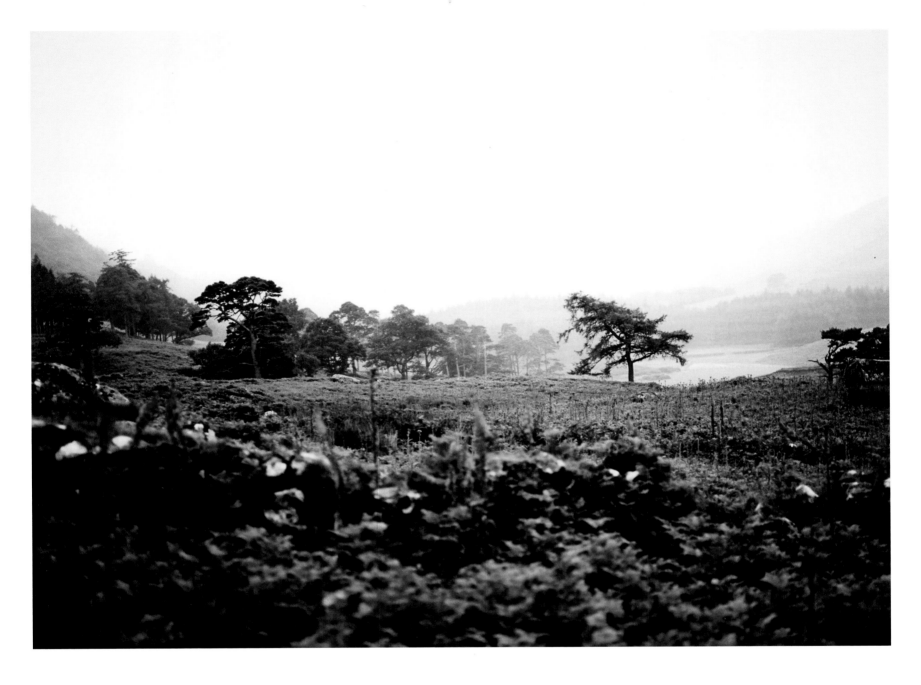

30
Sika skull
Camaderry

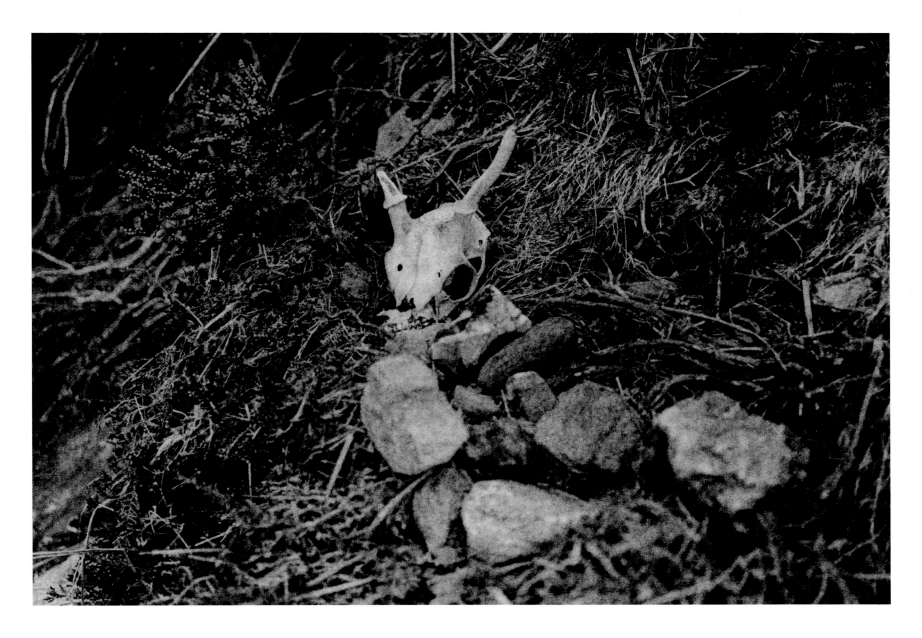

31
Rocks
Glenealo Falls

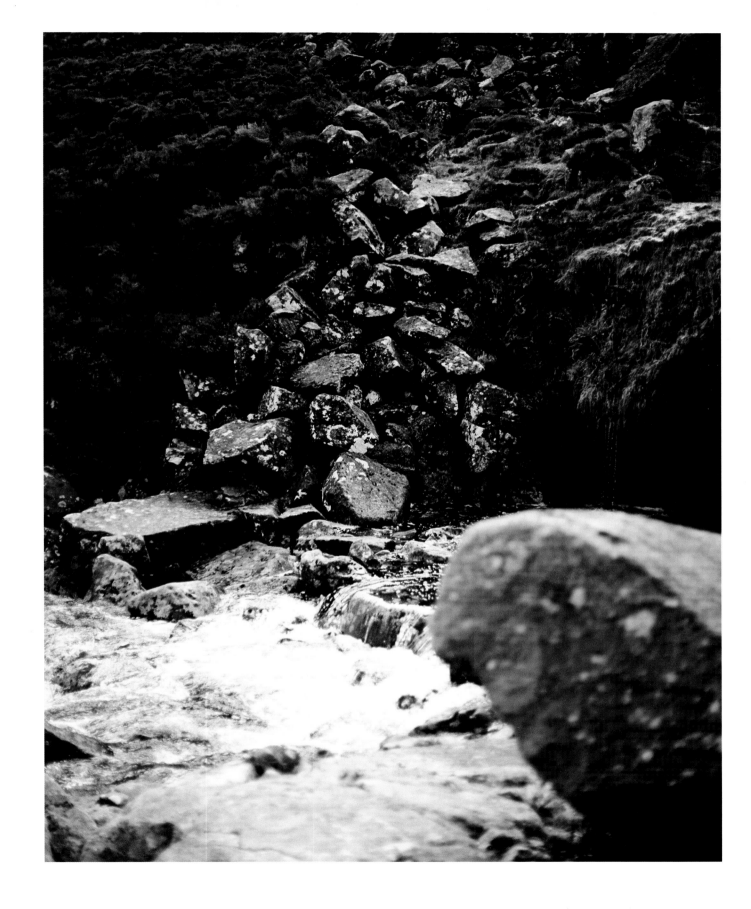

32
Rockpool
Glenealo

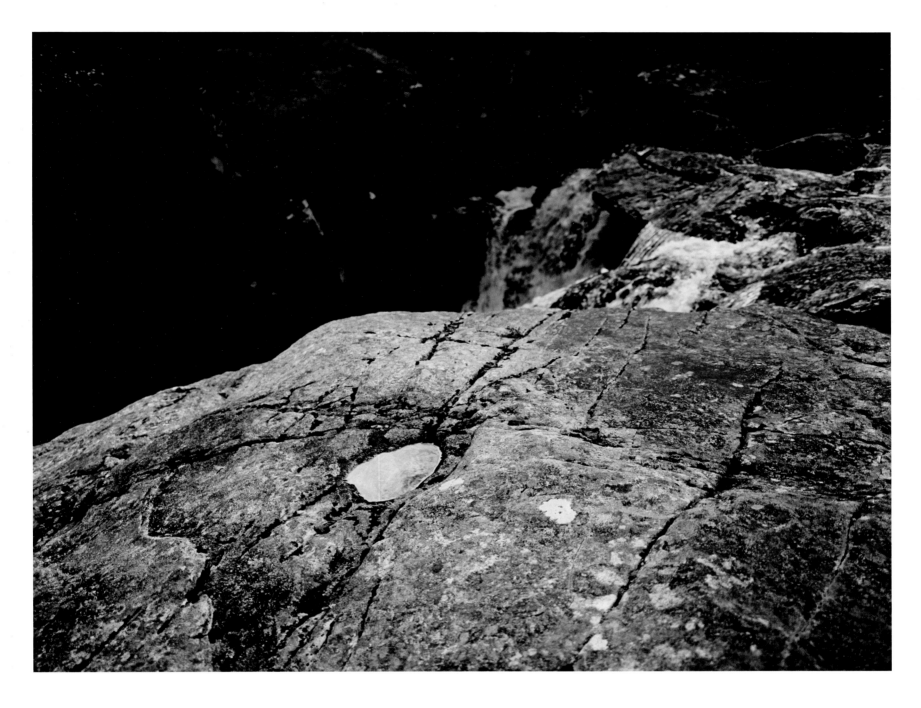

33
Rockpool and Falls
Glenealo

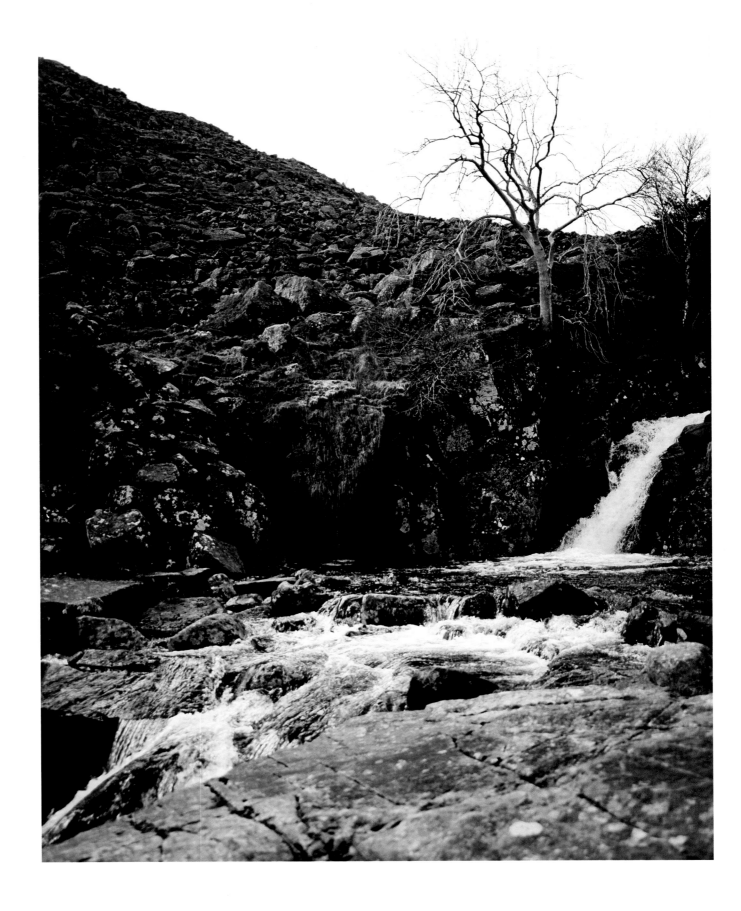

34
Wild Goats
Camaderry

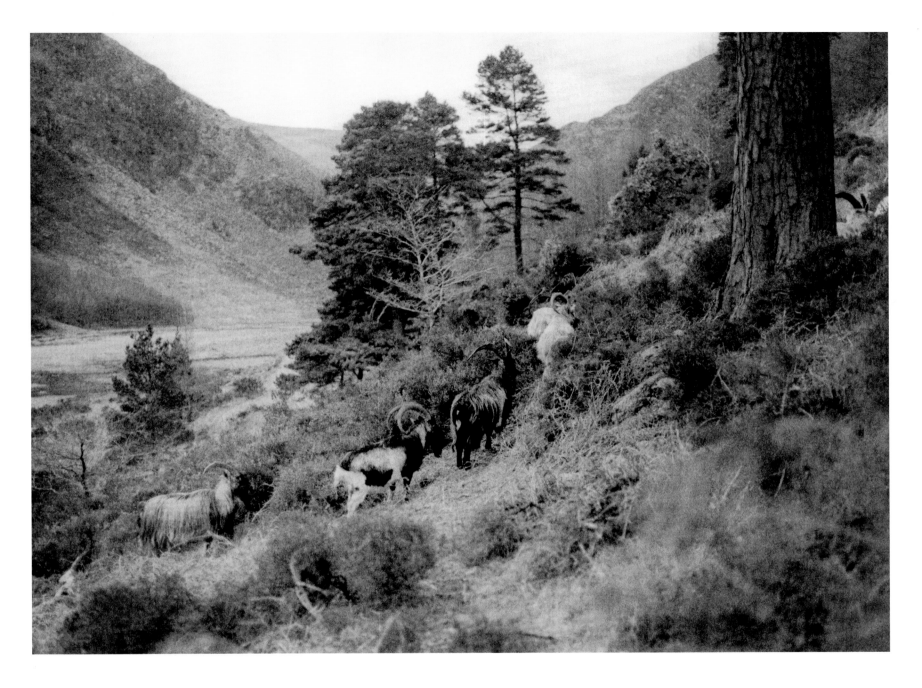

35
From Glenealo falls
towards Upper Lake
Glendalough

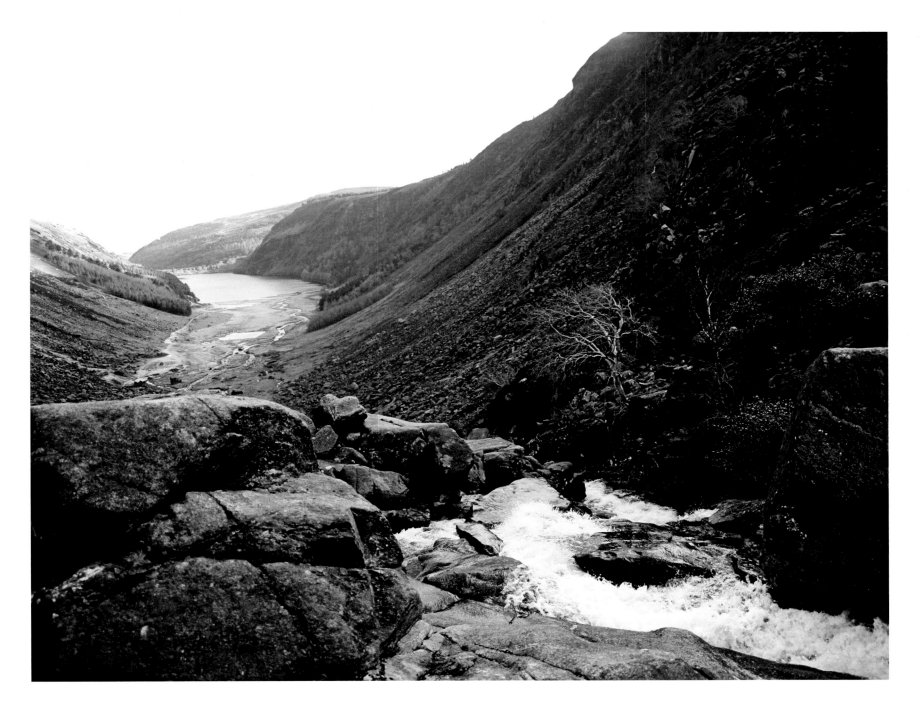

36
Bog Cotton
Sallygap

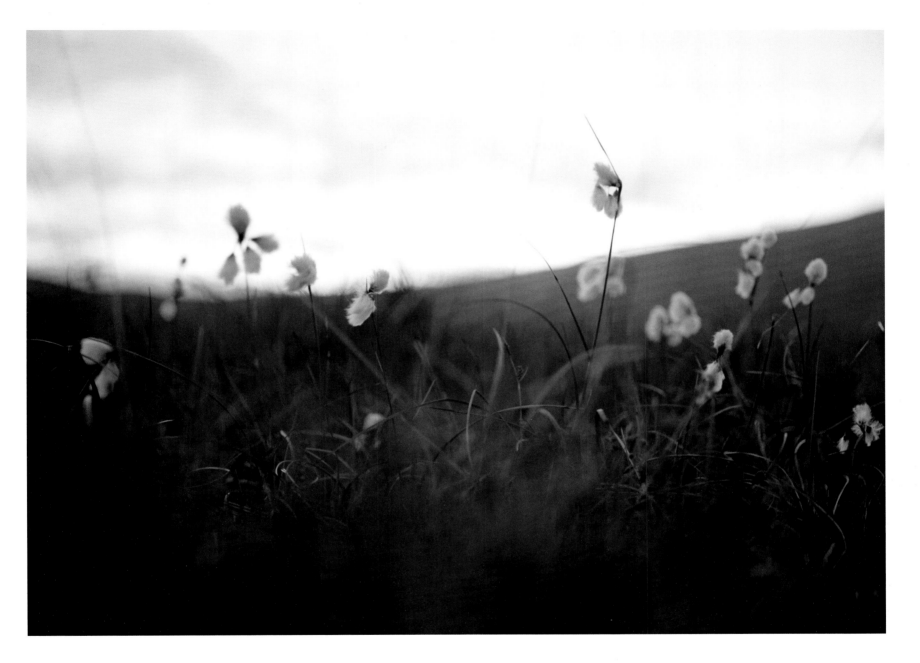

37
Winter
Poulinass

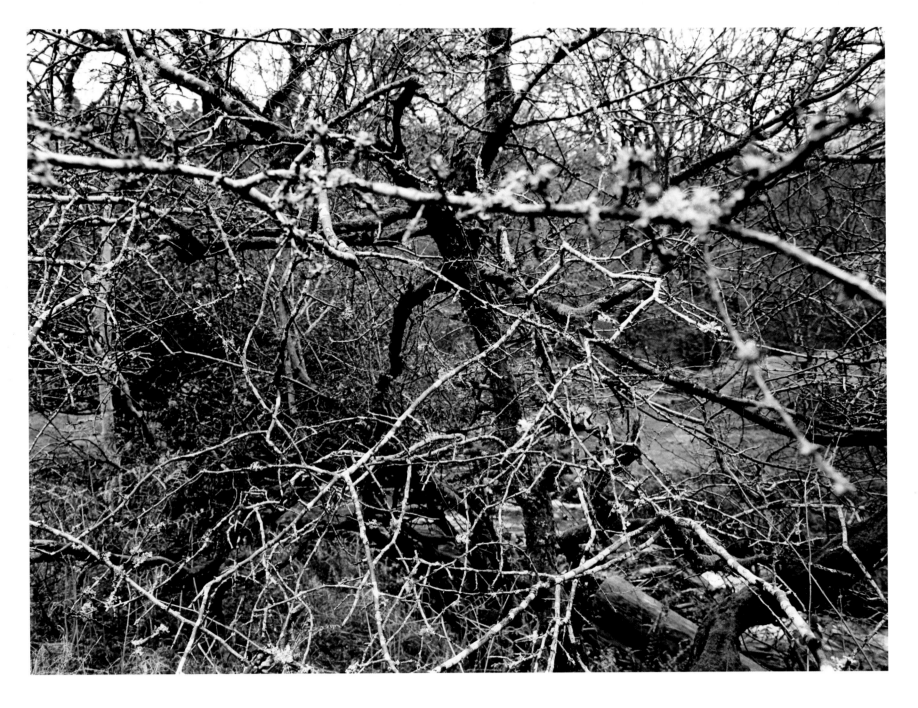

38
Gorse and Birch
Tomriland

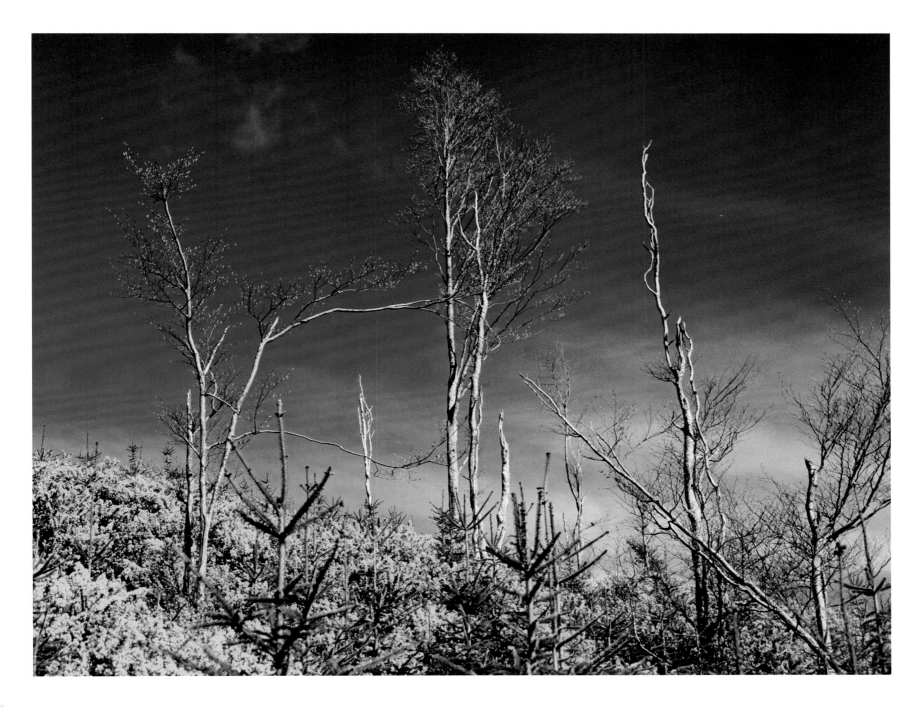

39
Beneath Sheepbanks
towards Lough Tay

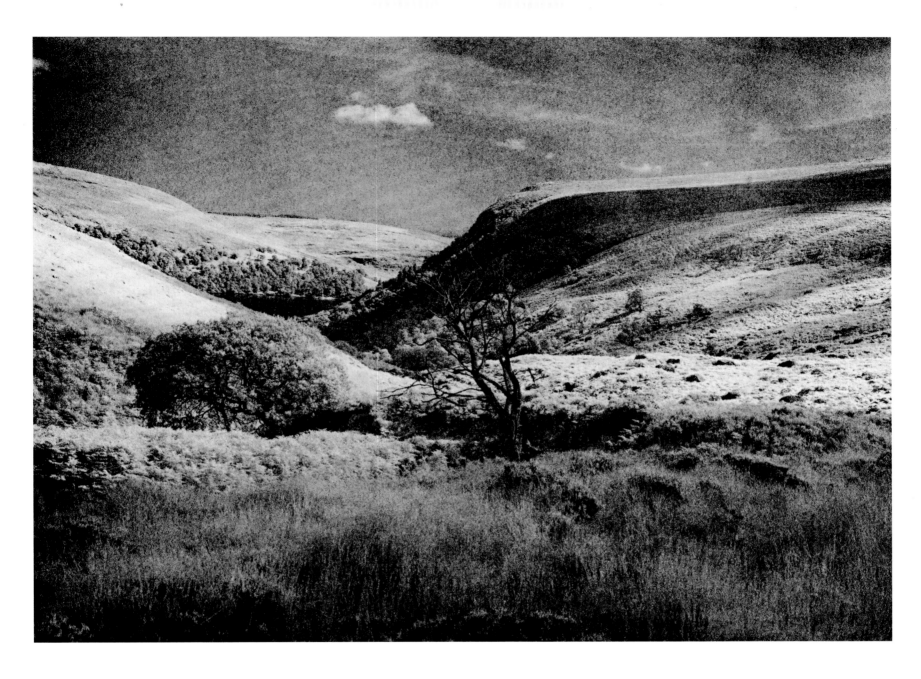

40
Pipers Brook
Lough Tay

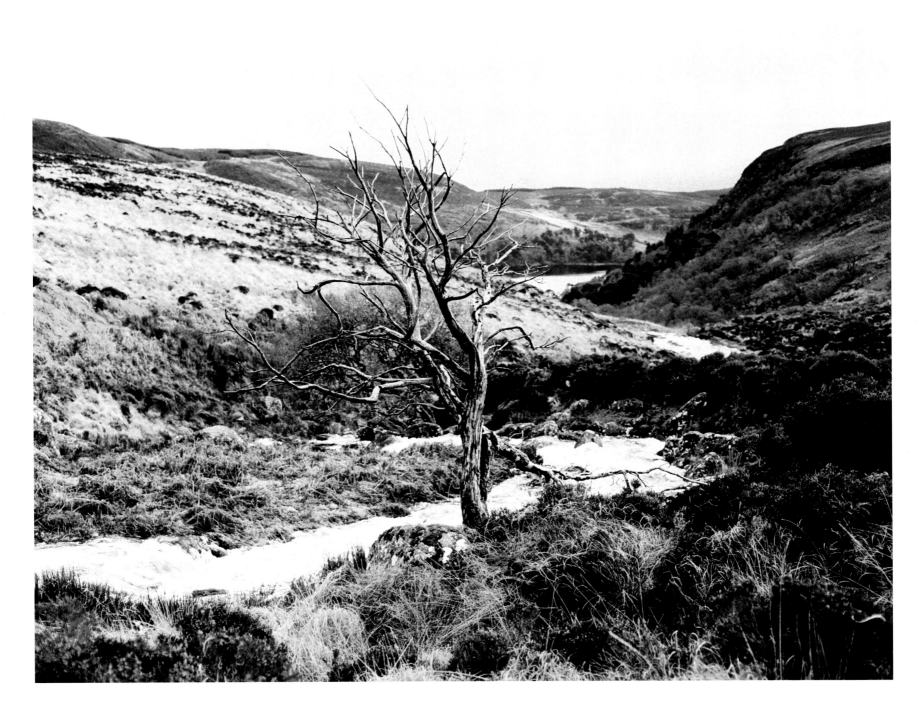

41
Green Tree at Pipers Brook
Lough Tay

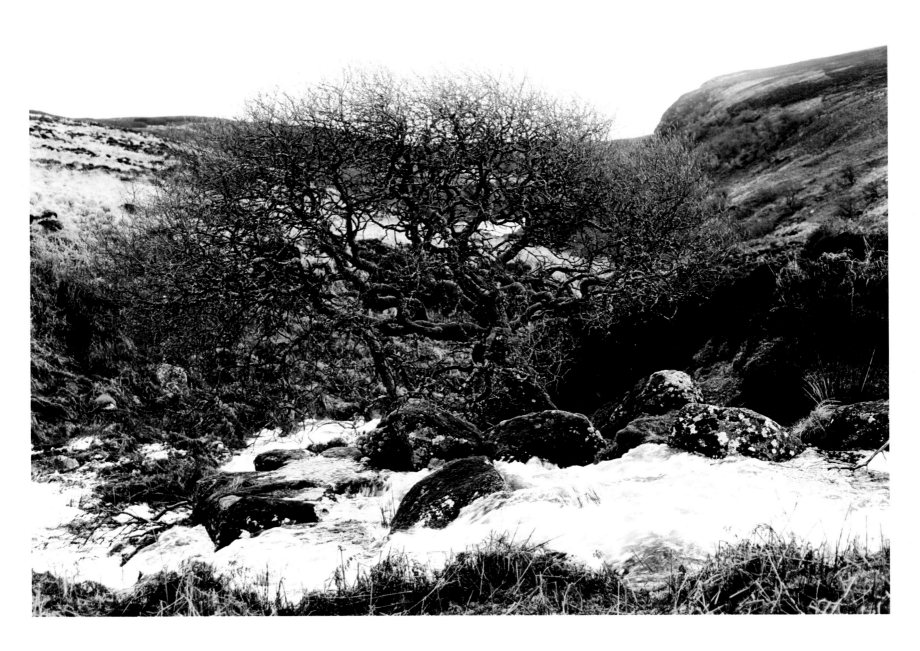

42
Wild Goats at Miners road
Glendalough

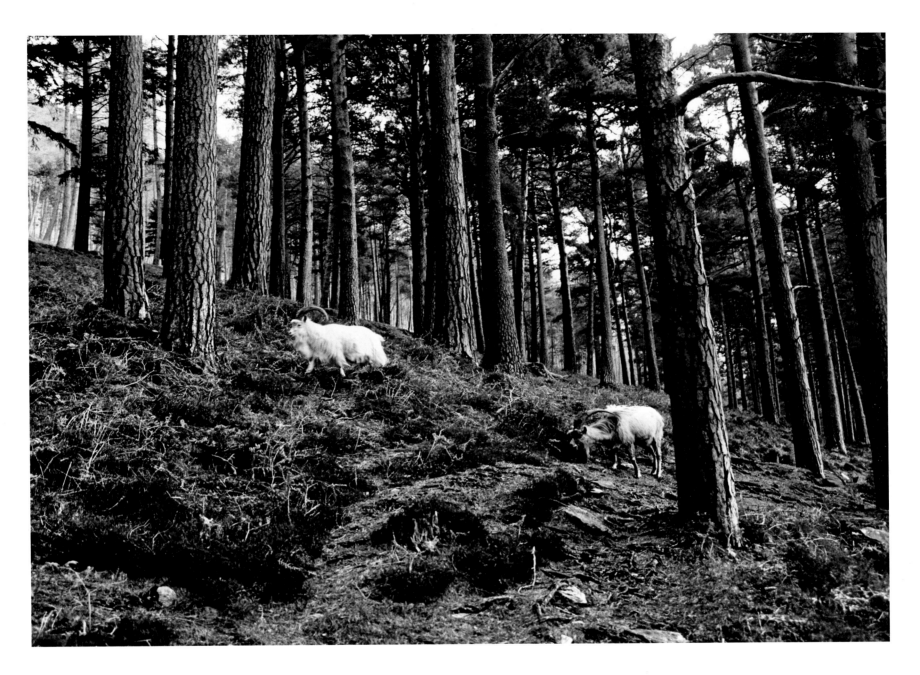

43
Wild Goats
Glendalough

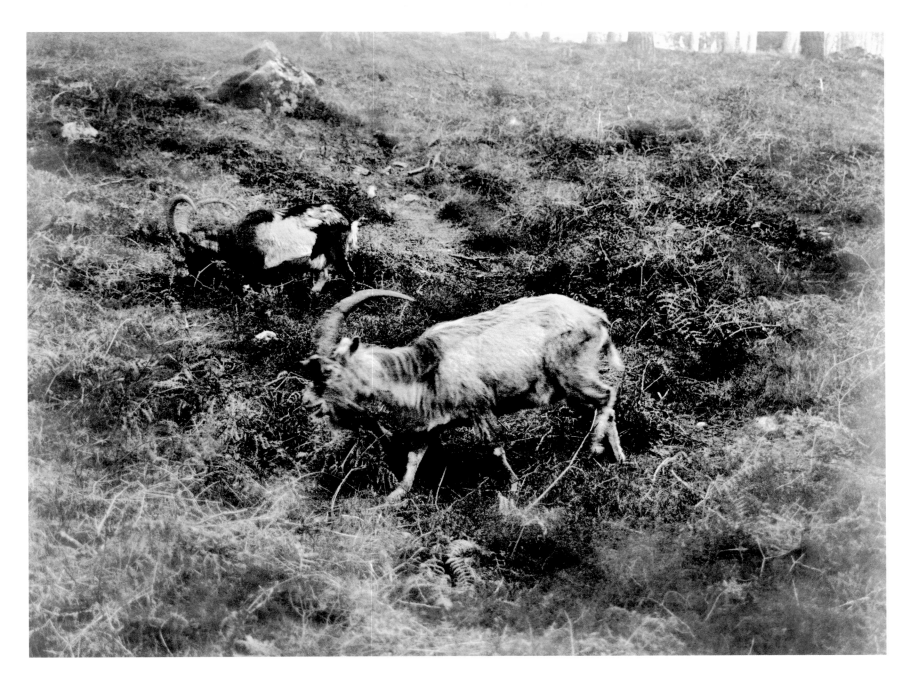

44
Stream
Glendalough

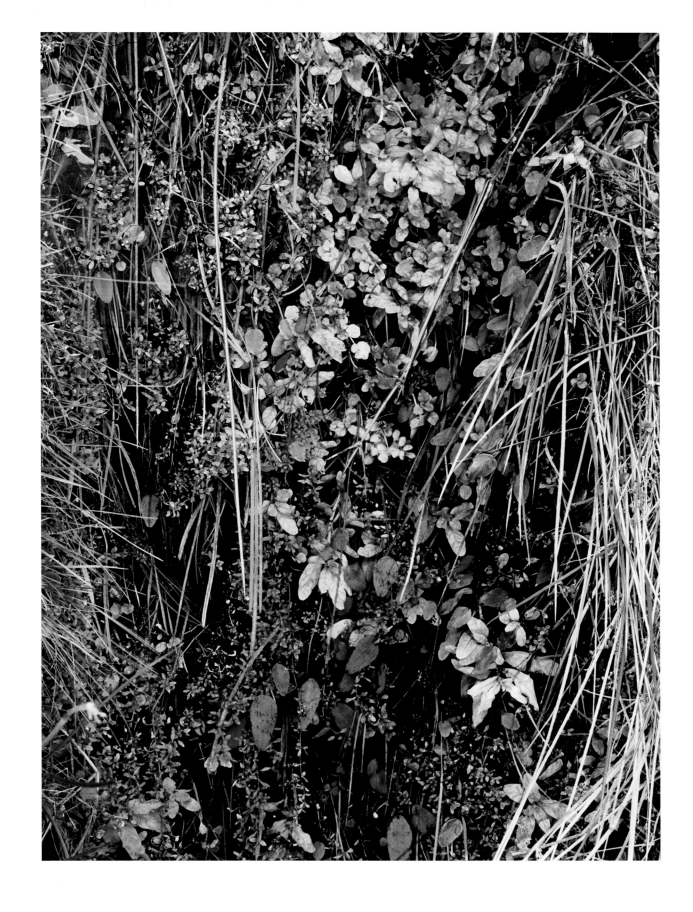

45
Stream
Glendalough

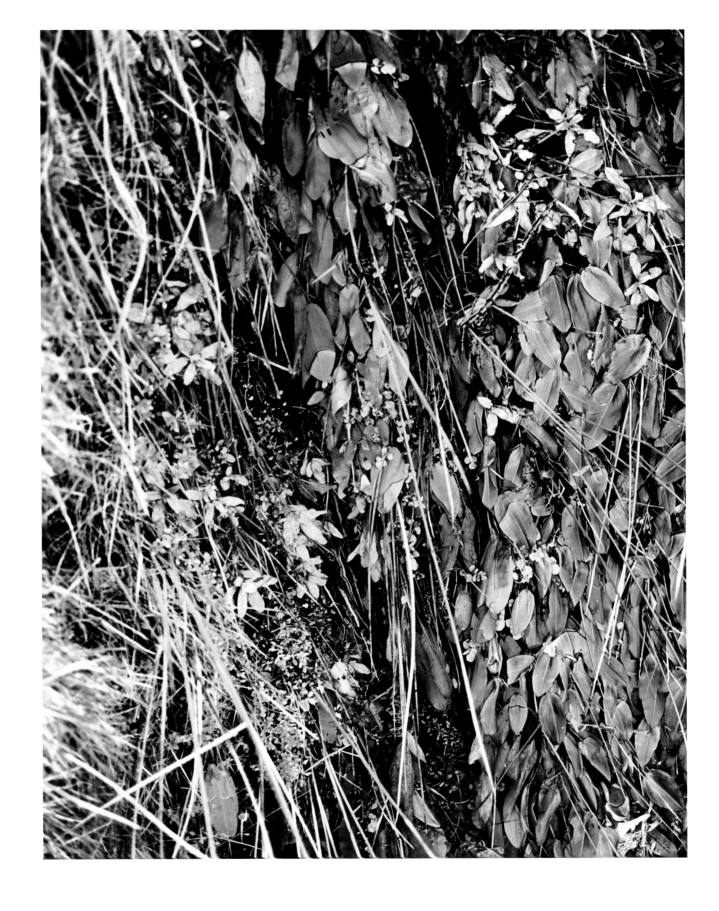

46
Sheeps skull
Glendalough

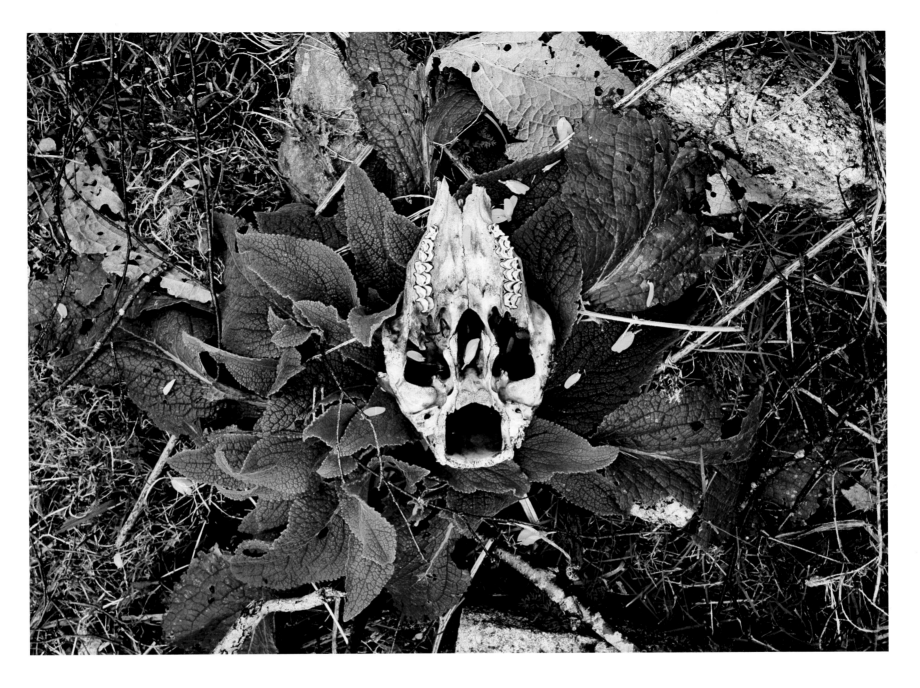

47
Horses
Bonagrew Little

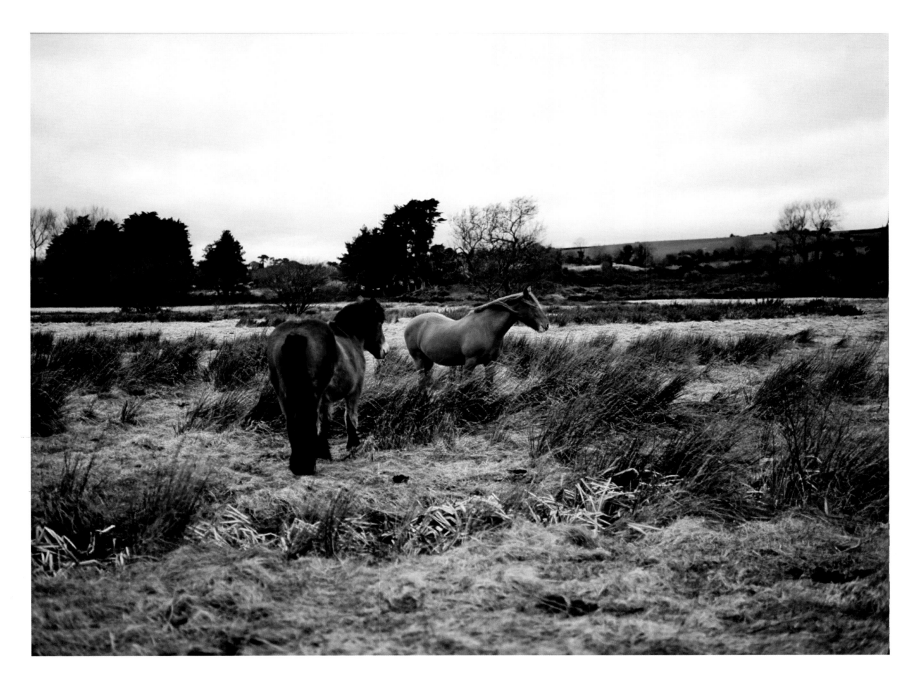

48
Horses
Bonagrew Little

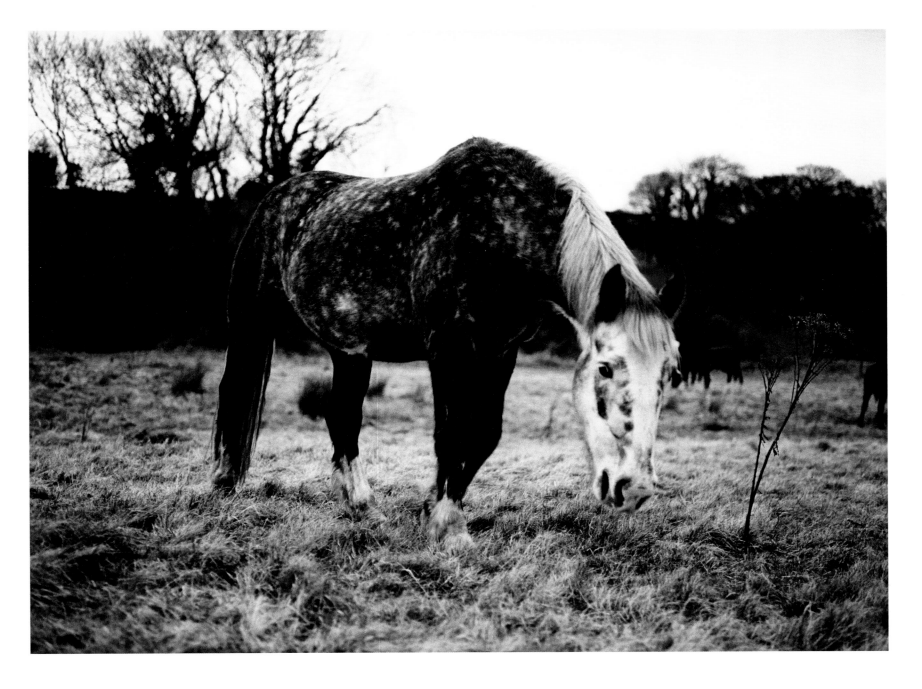

49
Avonmore River

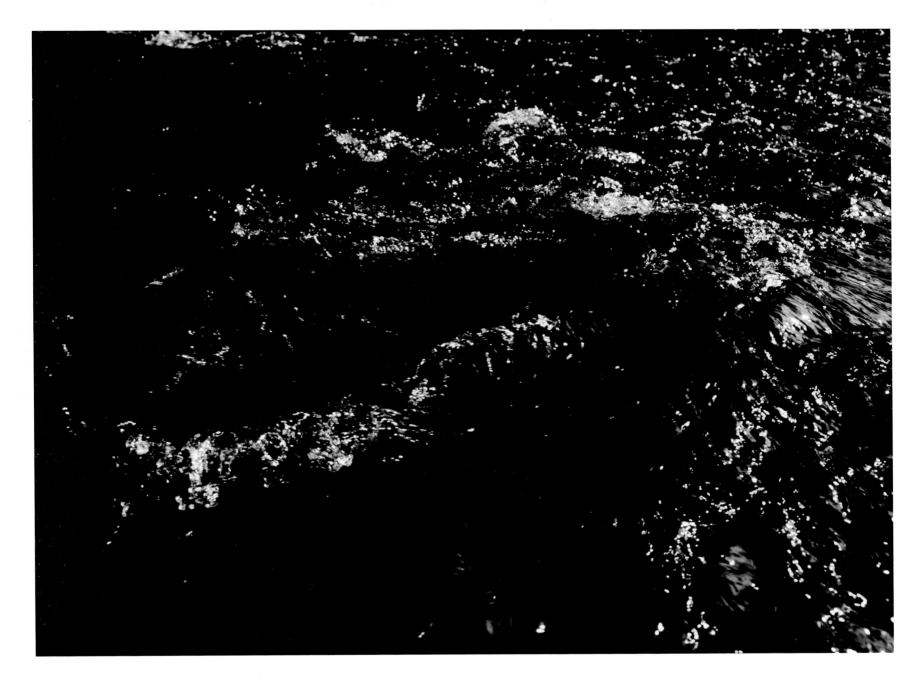

50
Avonmore River

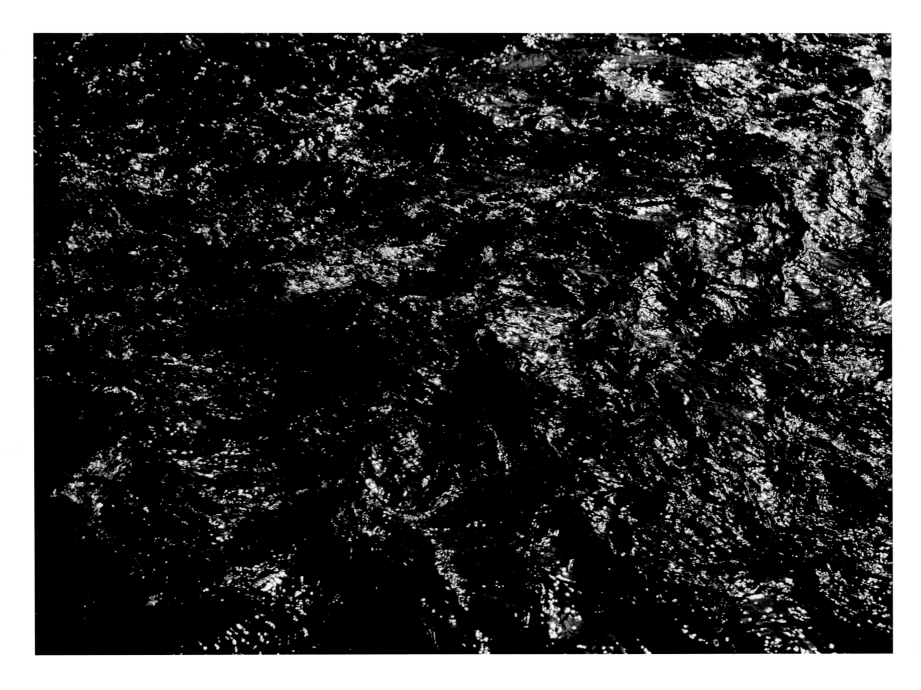

51
Avonmore River

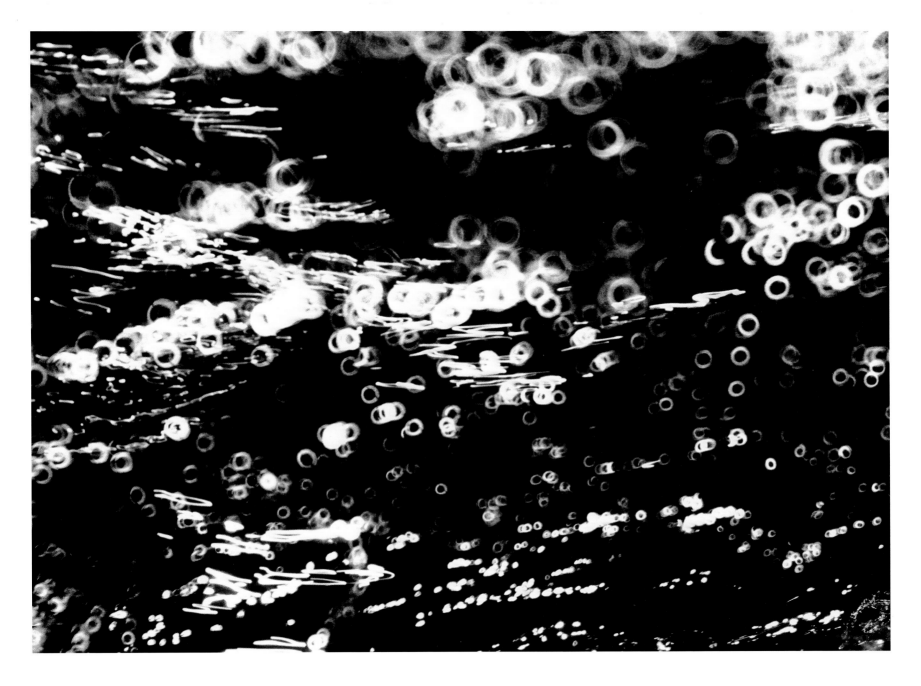

52
Tomriland

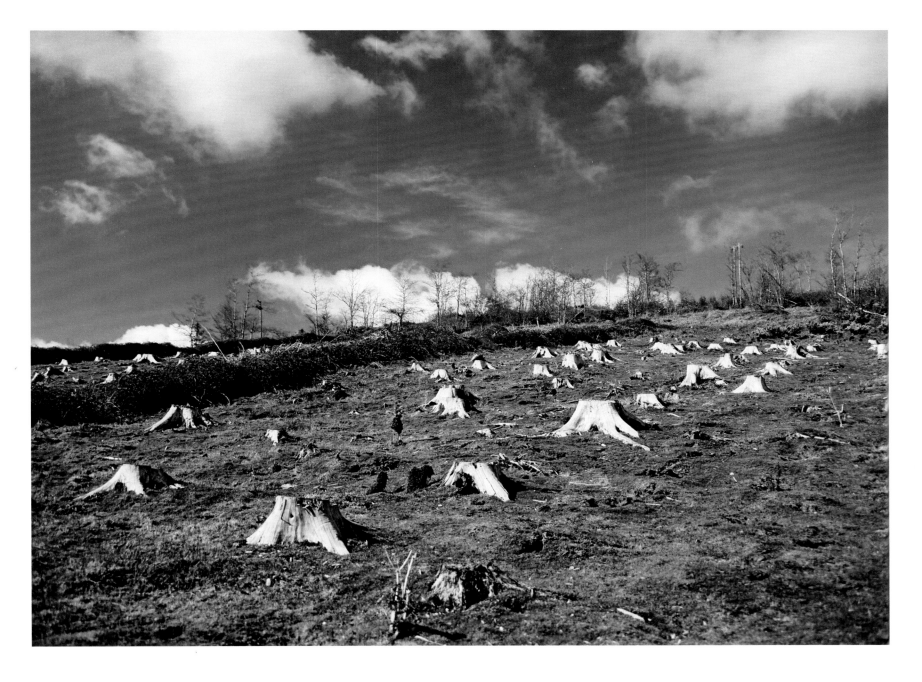

53
Green Road
Glendalough

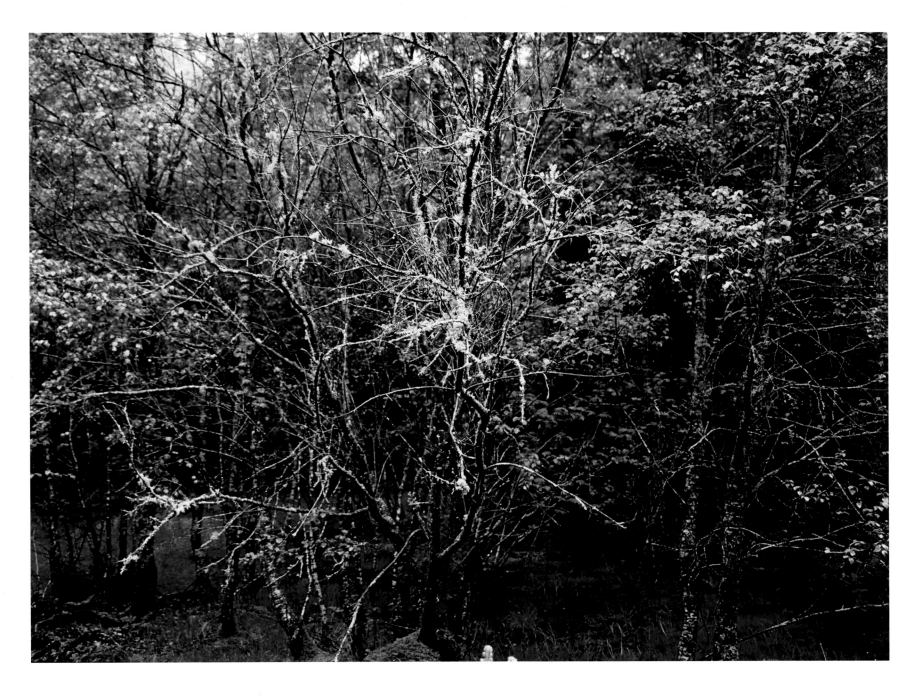

54
Cows
Glenmalure

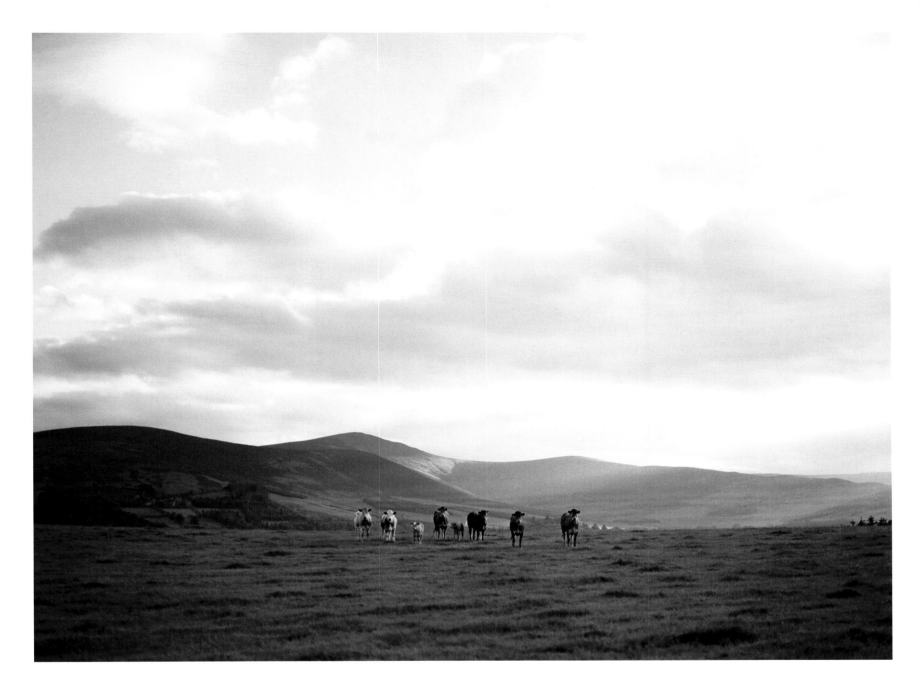

55
Johnnies Oaks
Lough Dan

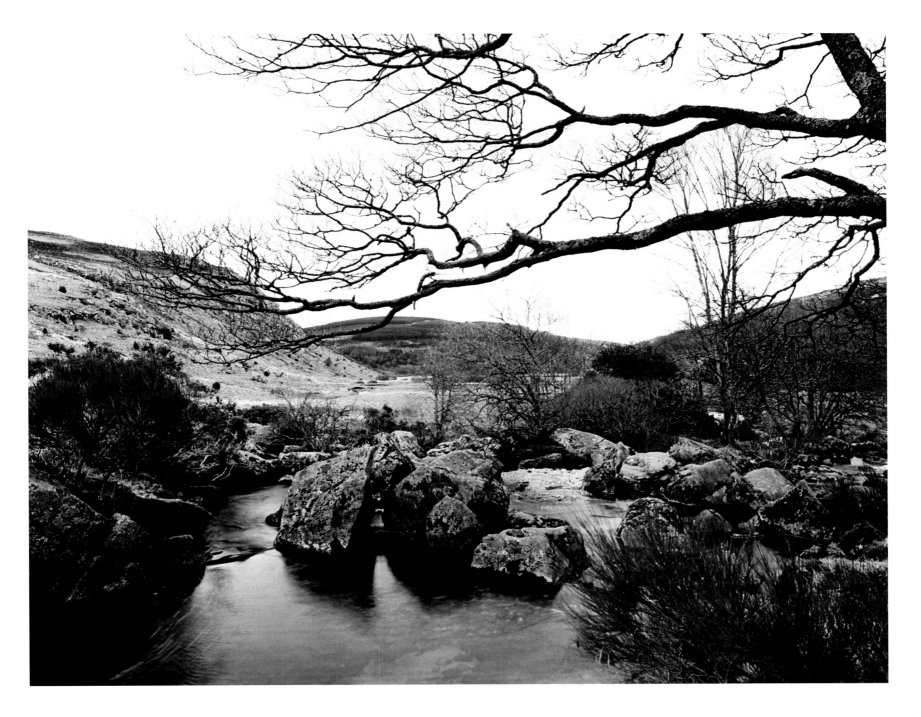

56
Deserted Caravan
Bonagrew

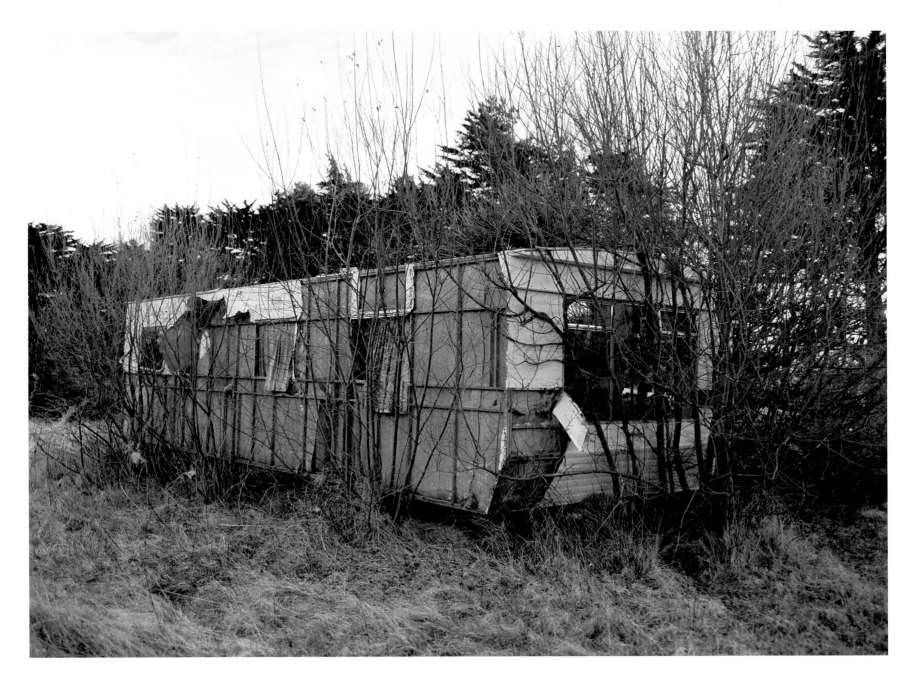

57
Deserted caravan
Bonagrew

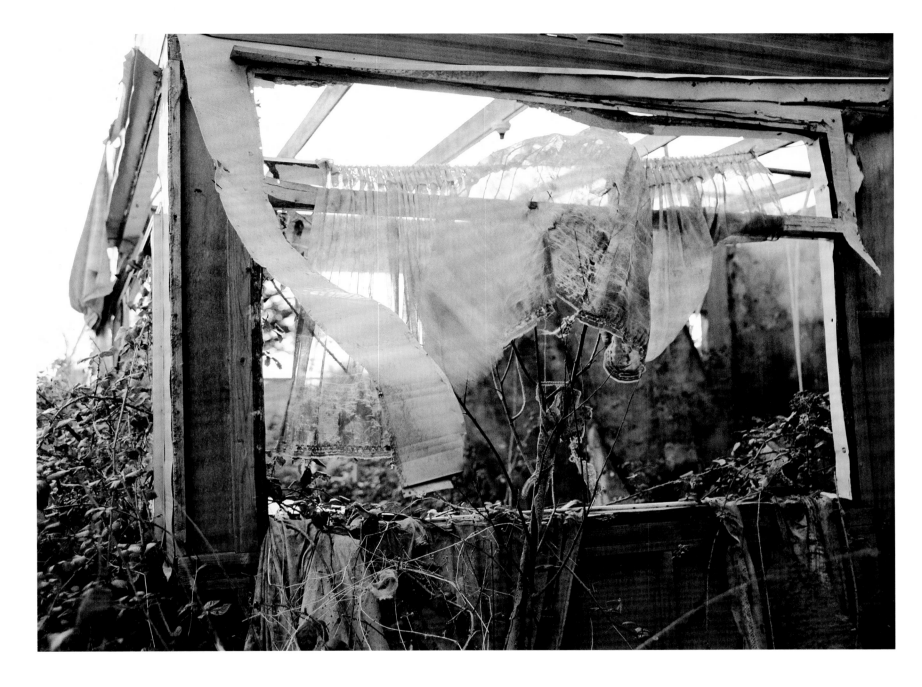

58
Deserted caravan
Bonagrew

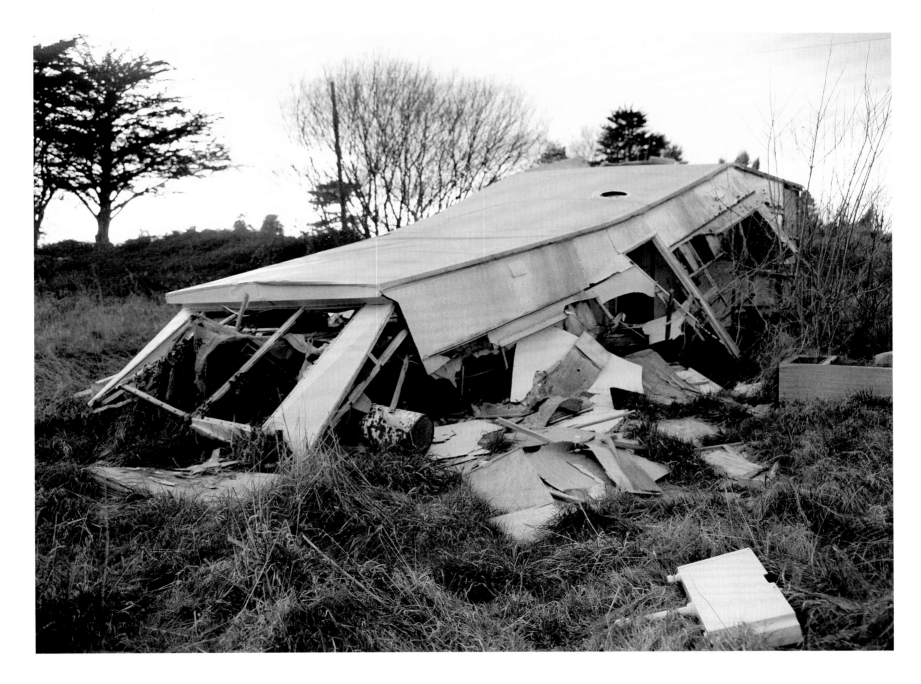

59
Sheep
Sallygap

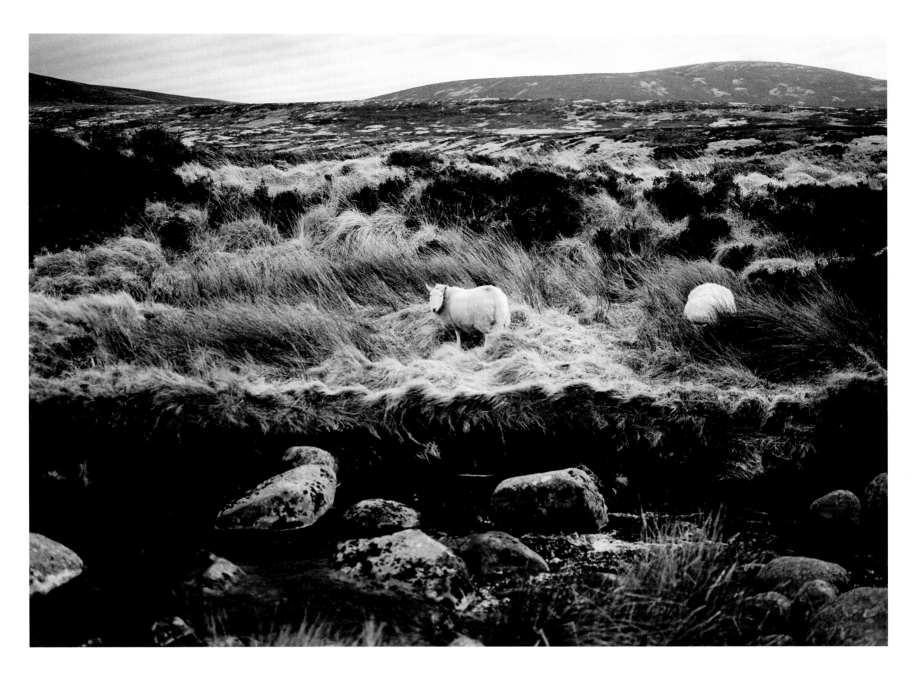

60
Sheep
Coronation Plantation

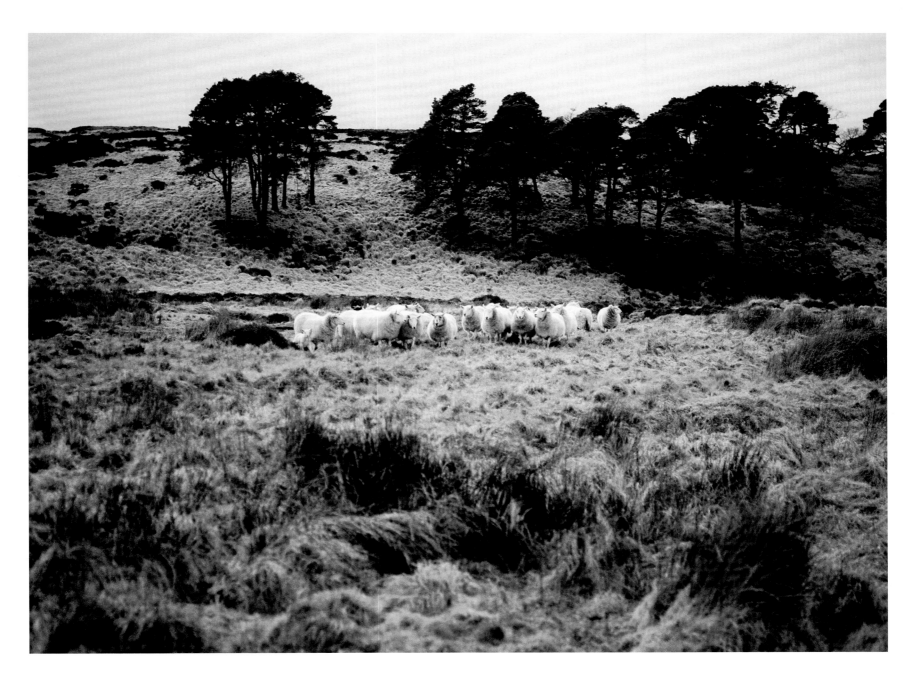

61
Scots Pine above River Liffey
Coronation Plantation

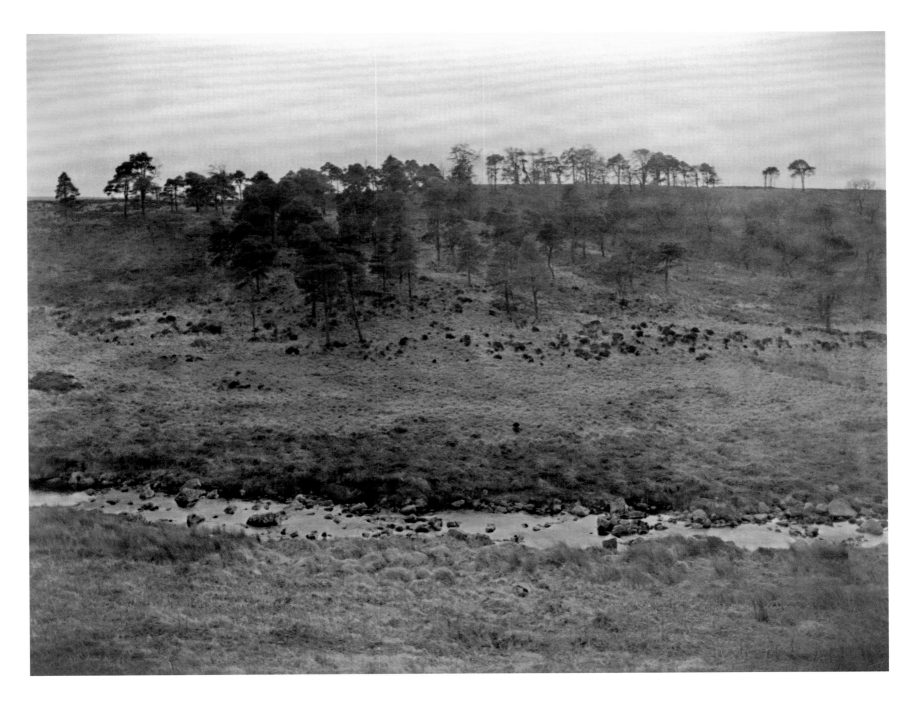

62
Scots Pines
Coronation Plantation

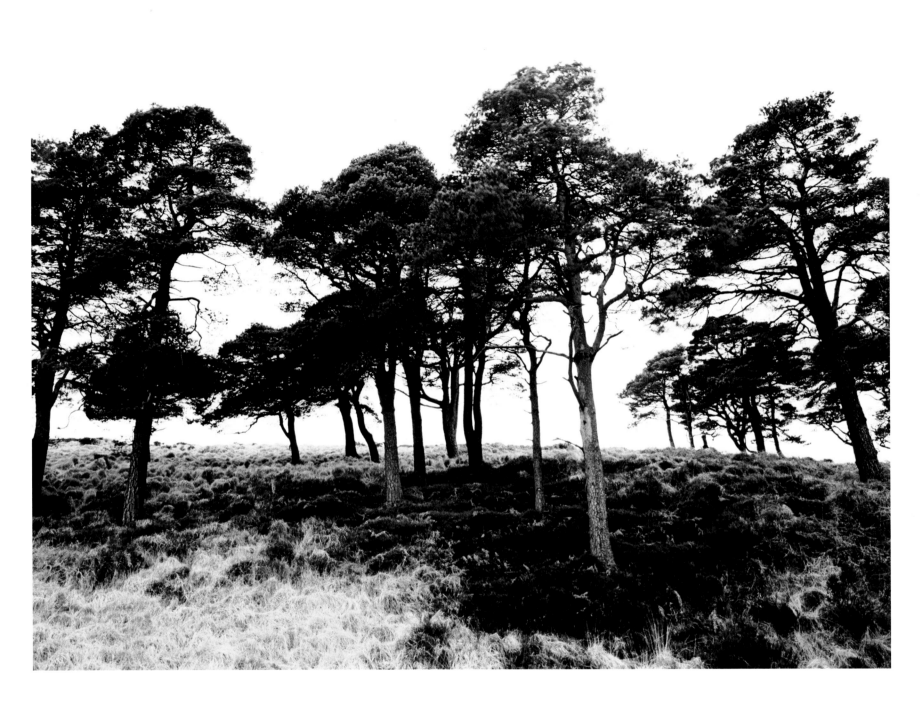

63
Scots Pine and River Liffey
Coronation Plantation

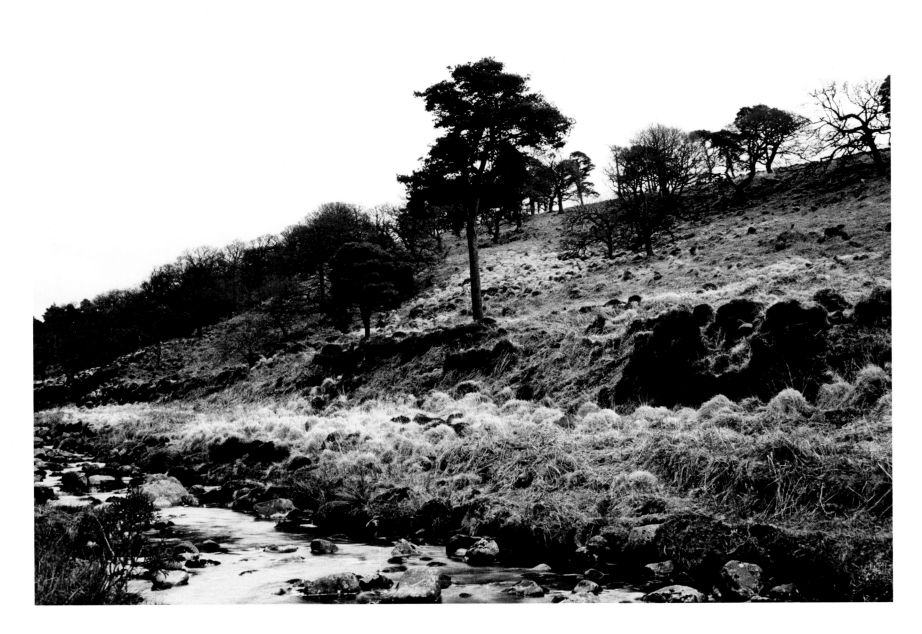

64
River Liffey
Coronation Plantation

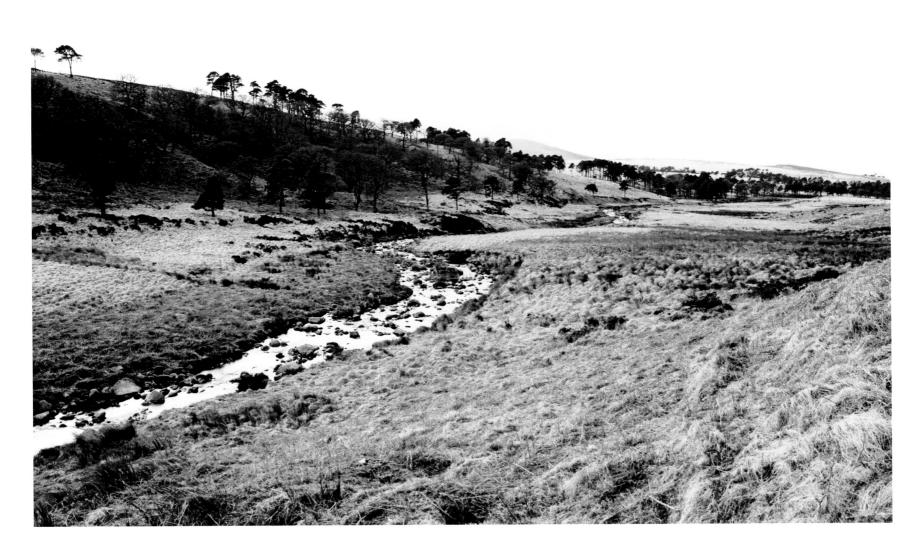

65
Moolight
Glendalough Estate

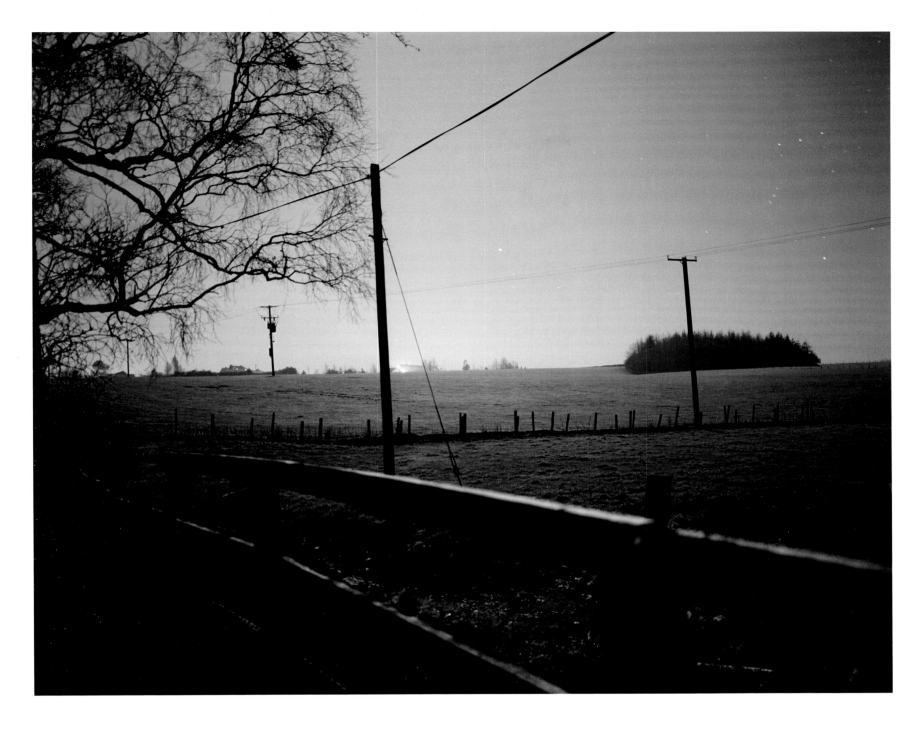

66
Moonlight
Glendalough Estate

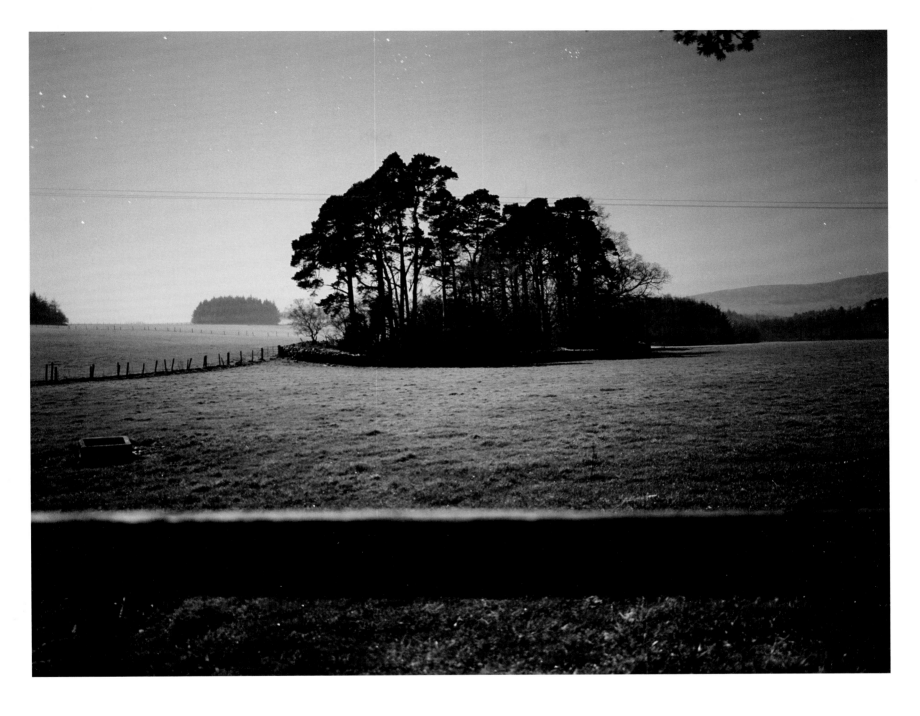

67
Moonlight on Maize Field
Annamoe

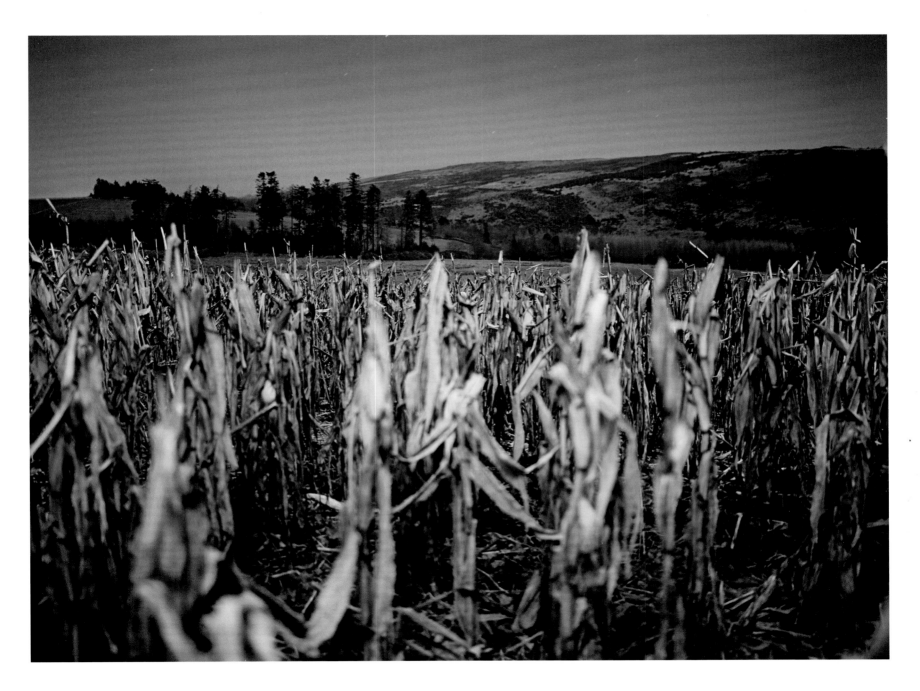

68
Deer at Miner's Village
Glendalough

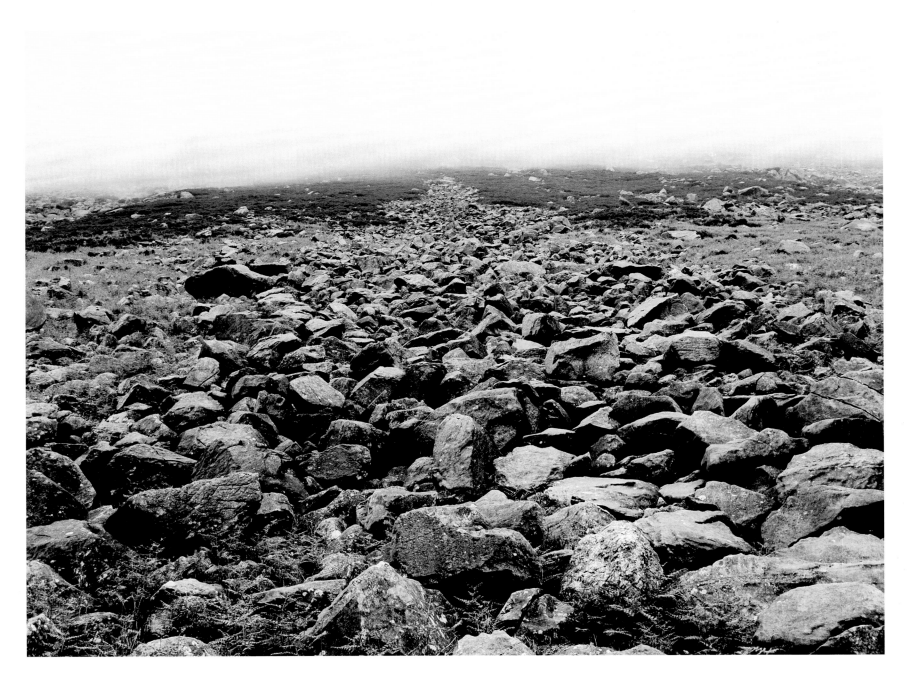

70
Woods
Lugalla

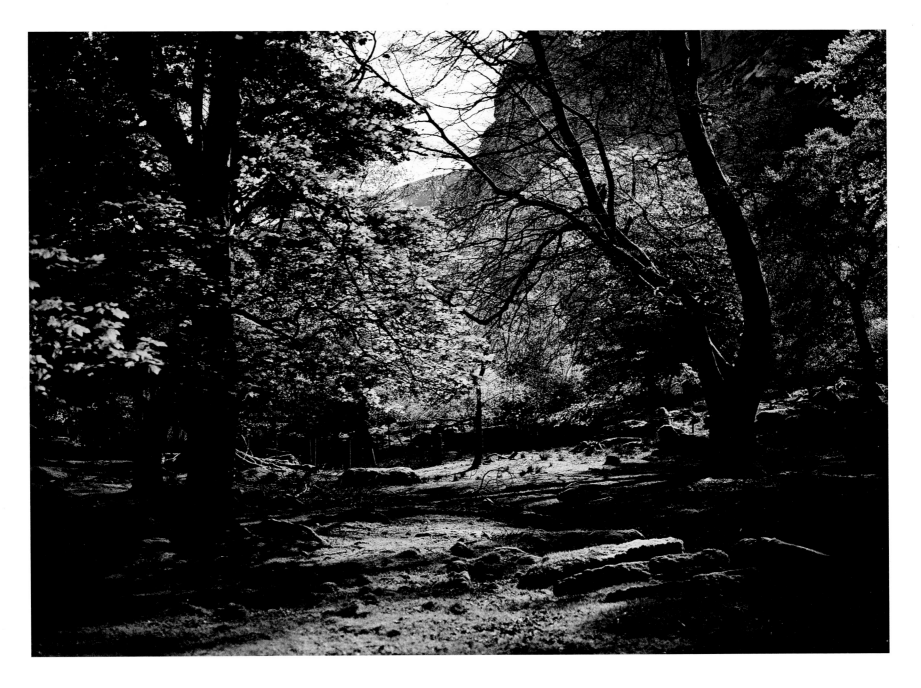

71
Cloghoge River

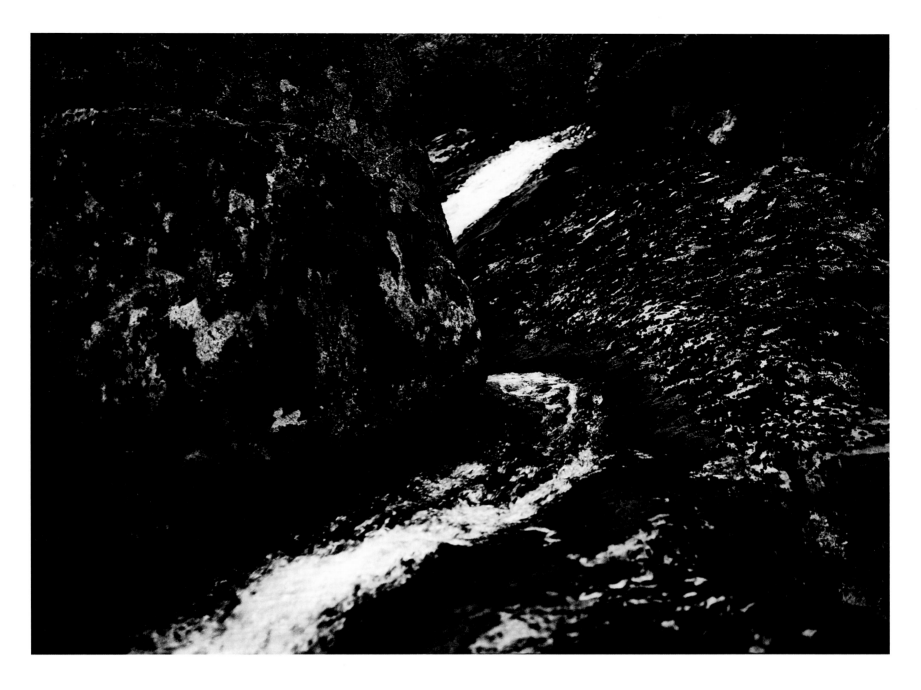

72
Cloghoge Rockpool

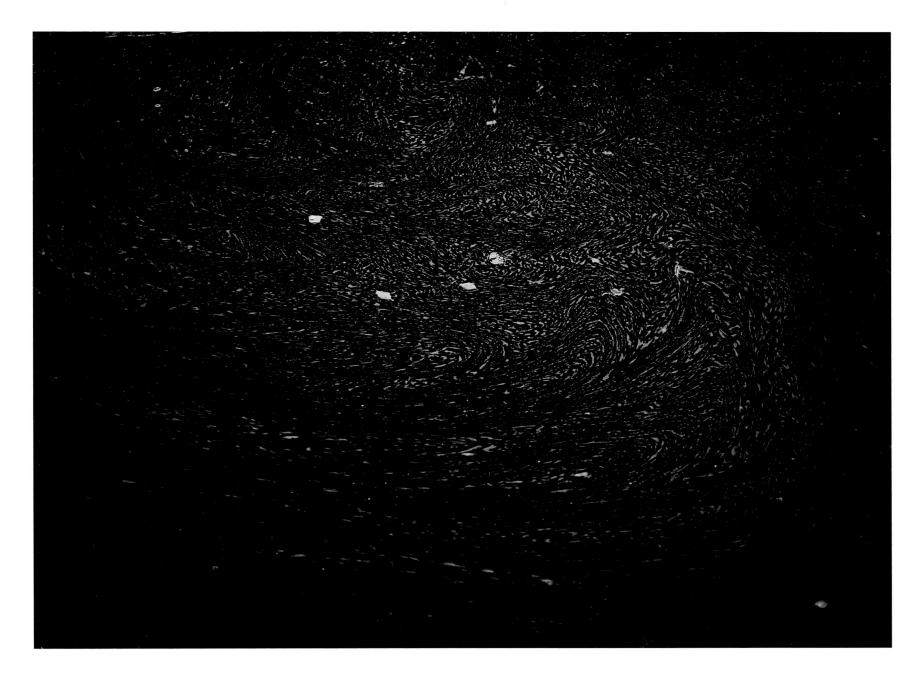

73
Dying Trees
Lugalla

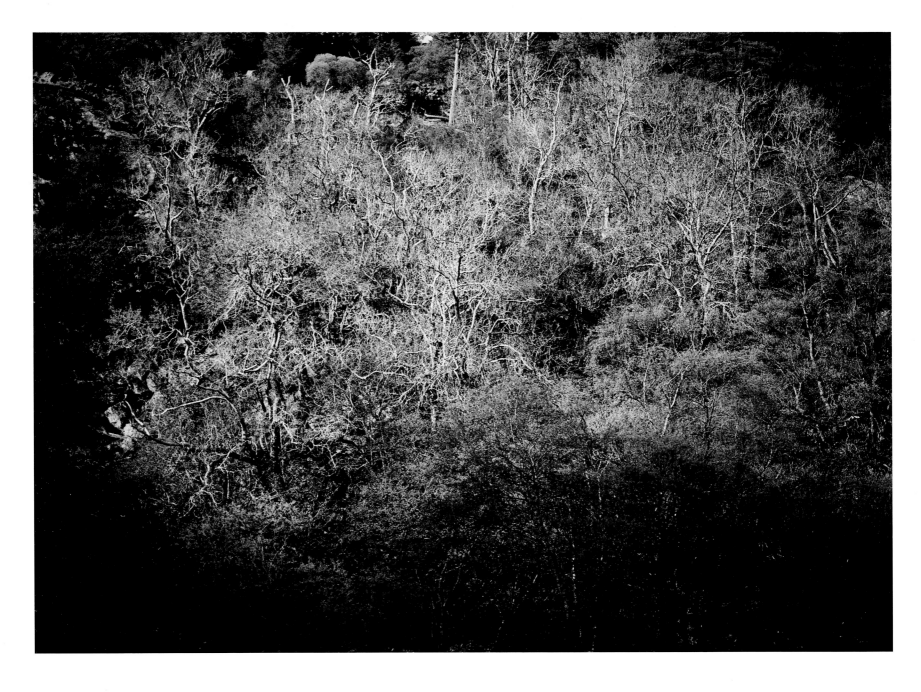

74
Rockpool Cloghoge River

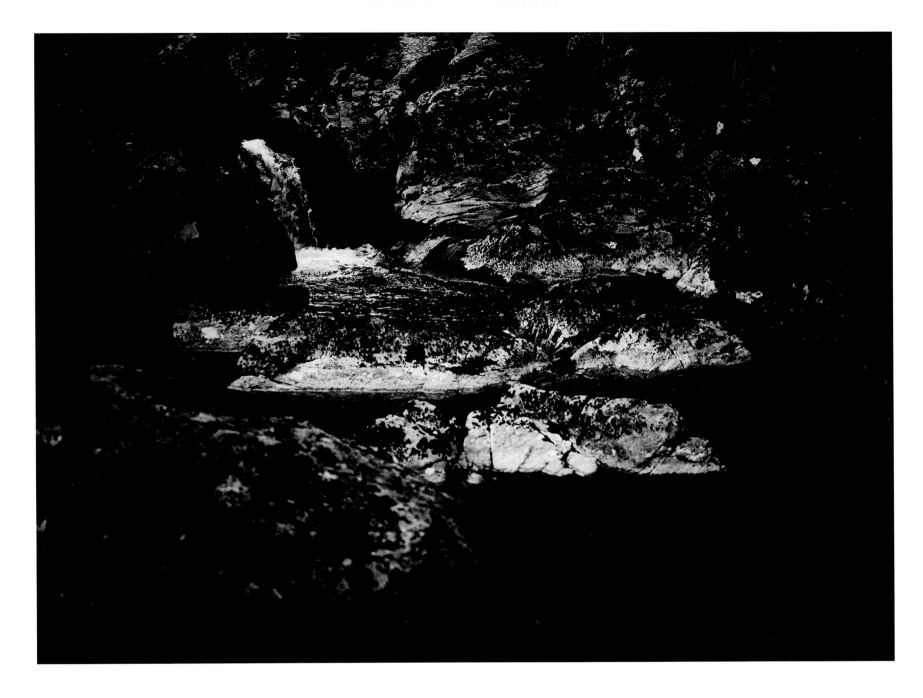

75
Woods at Nunns Cross

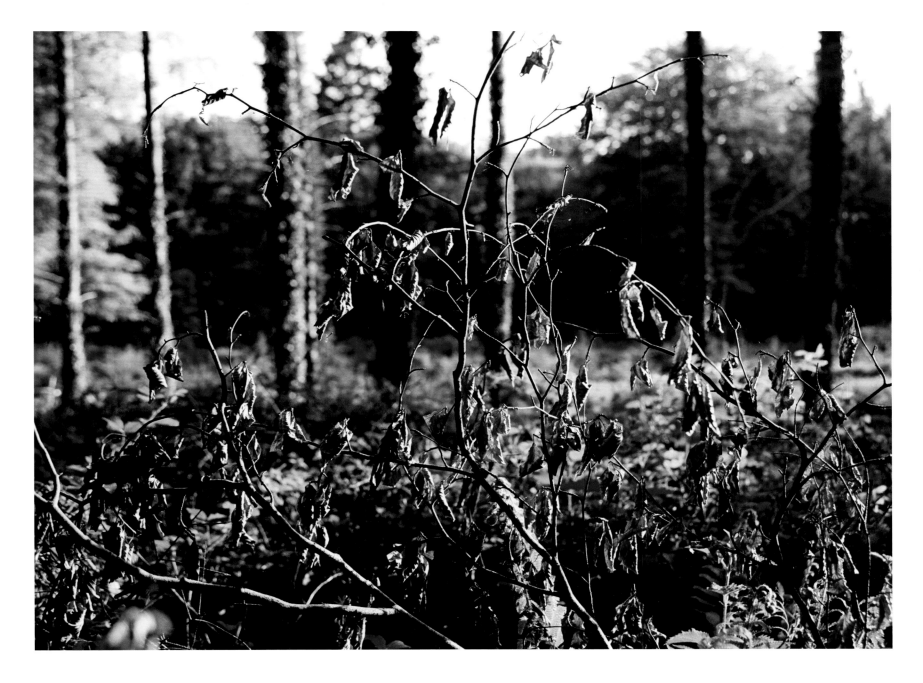

76
Wild garlic
Nunn's cross

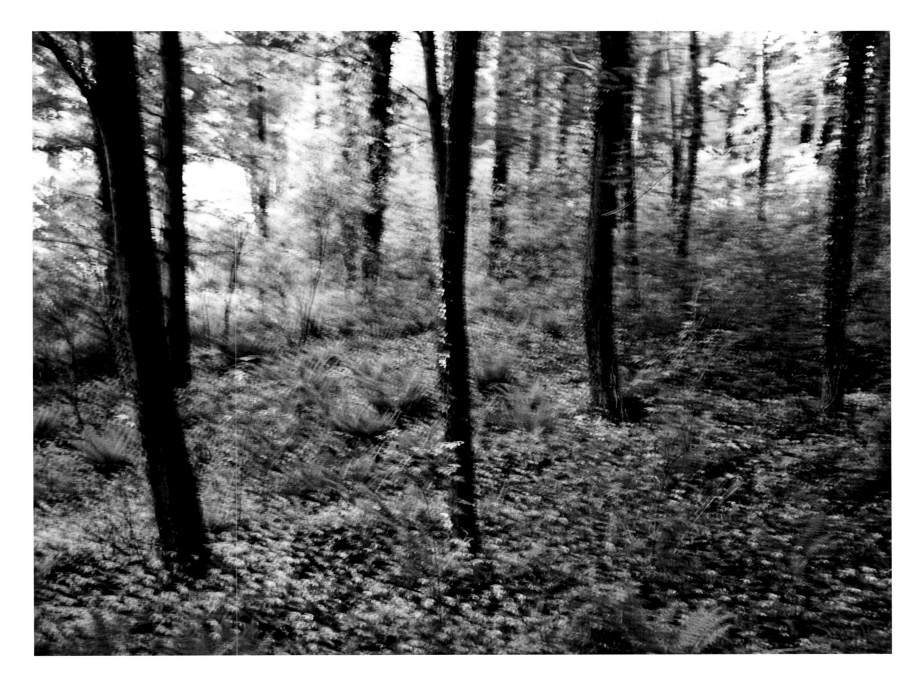

77
Wild Garlic
Avondale

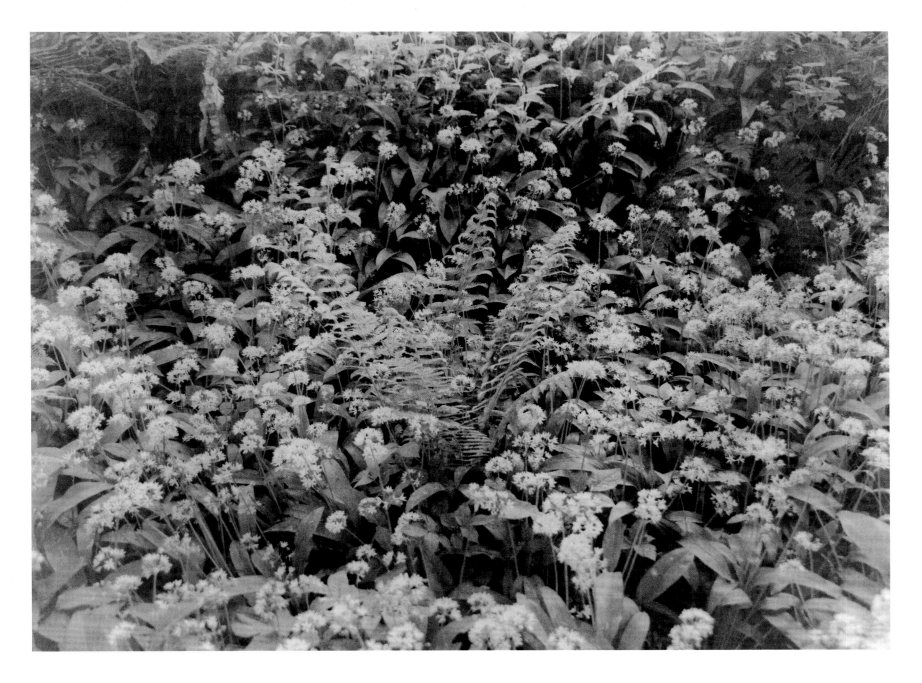

78
Donkeys
Annamoe

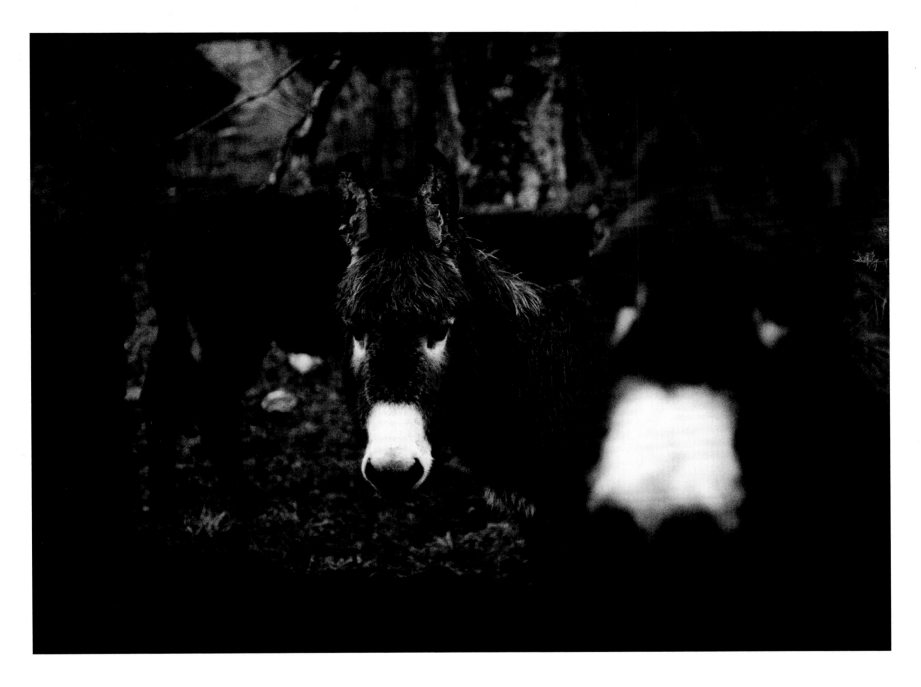

79
White Donkey
Annamoe

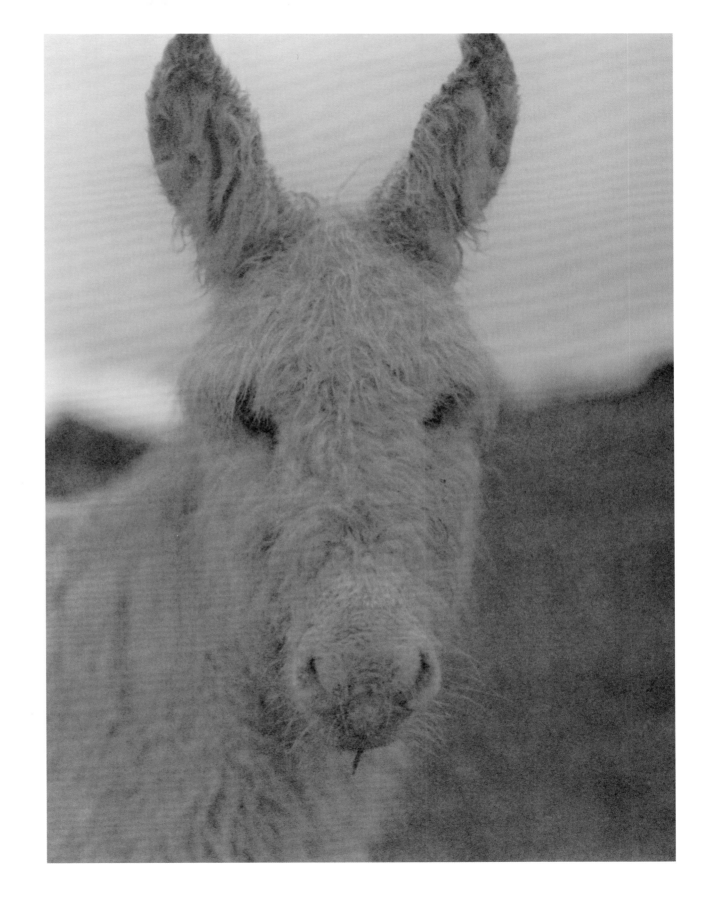

80
Towards Lough Tay

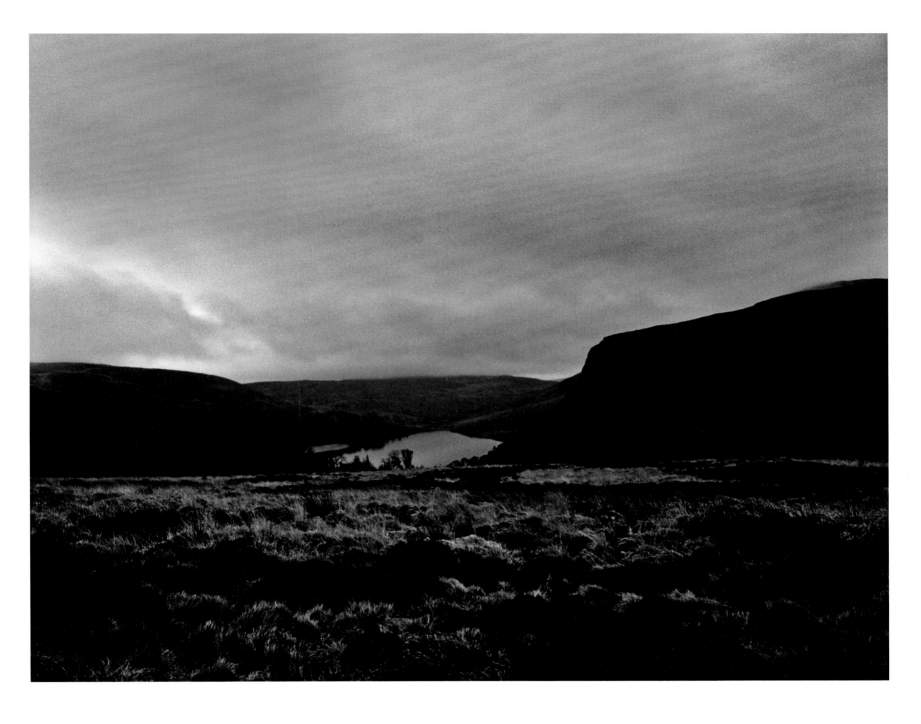

81
Birch at The Vale of Clara

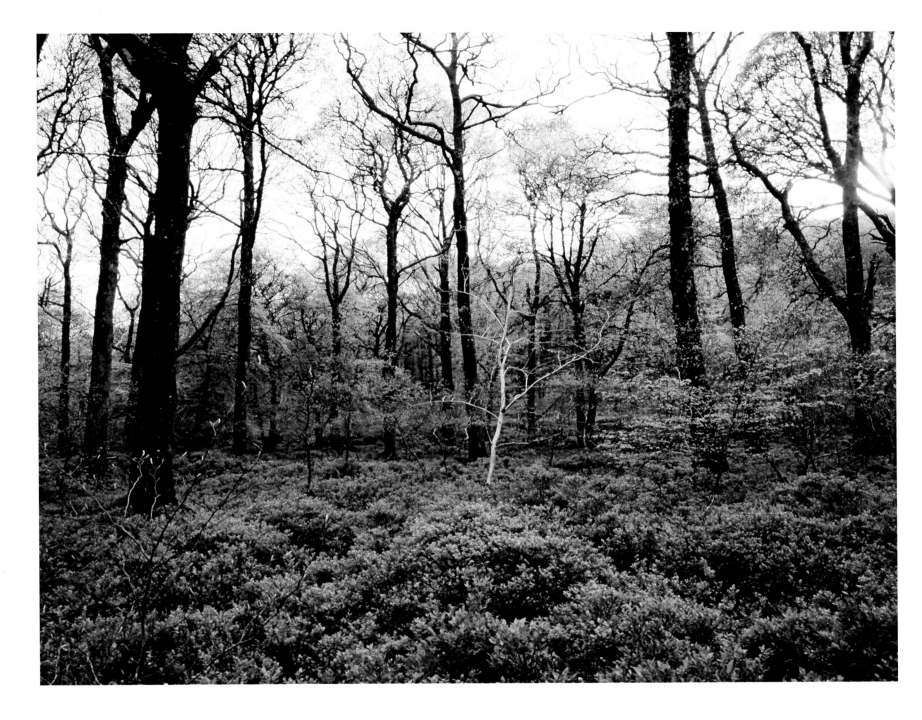

82
Native Oaks on Fancy Mountain

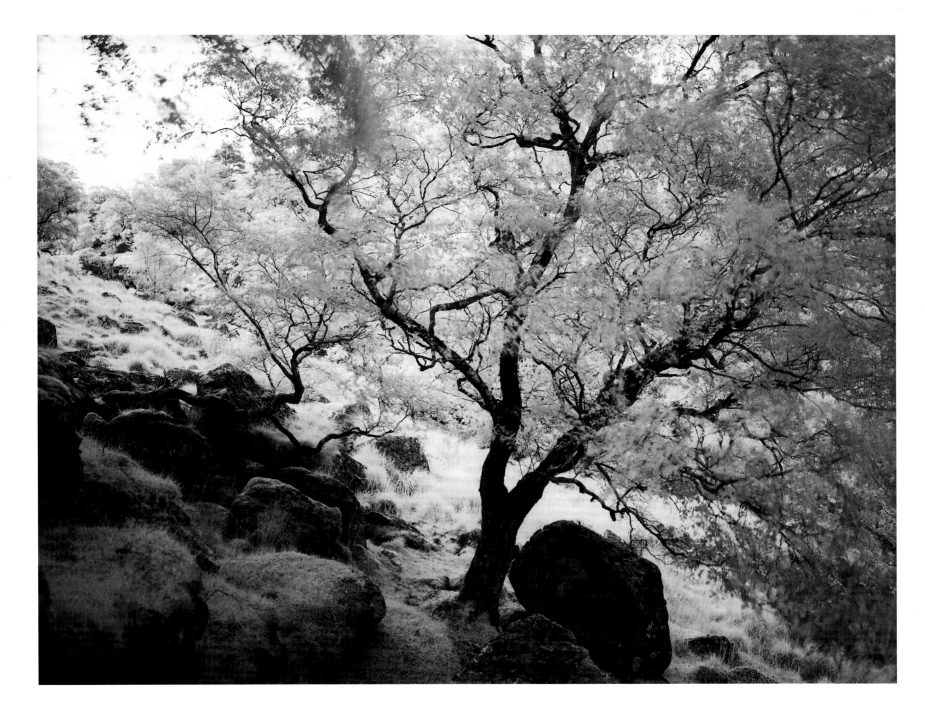

83
Cloghoge Falls

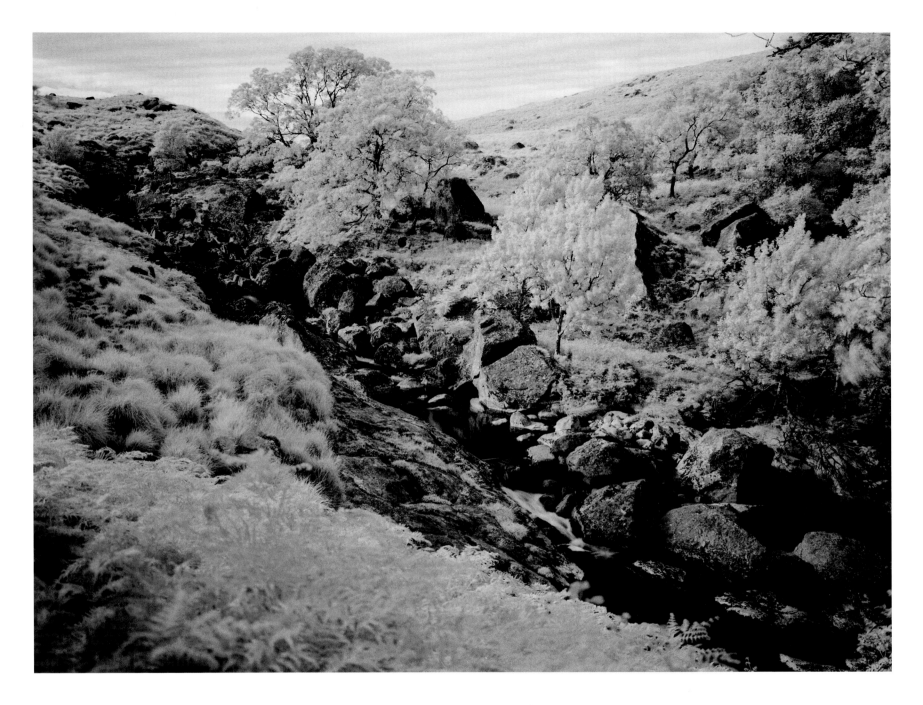

84
Native Oaks above Lough Tay

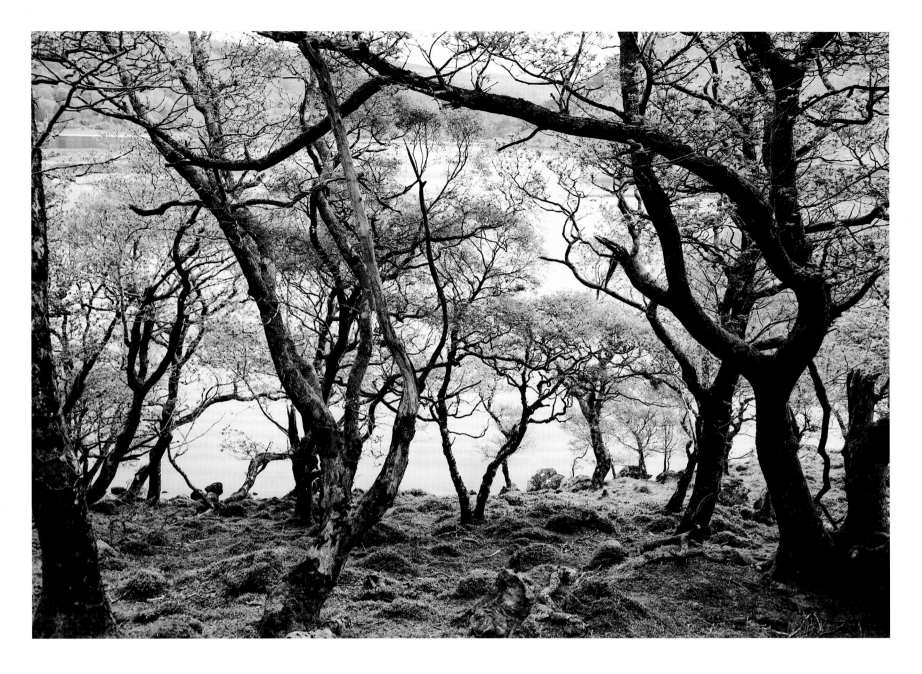

85
Spring Leaves
Lugalla

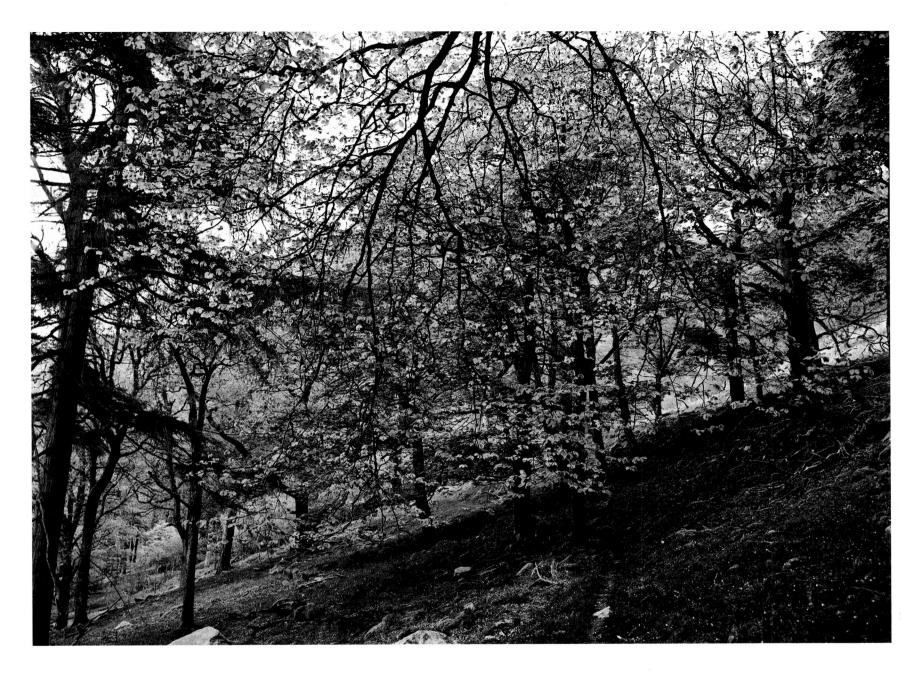

86
River Foam
Glenealo

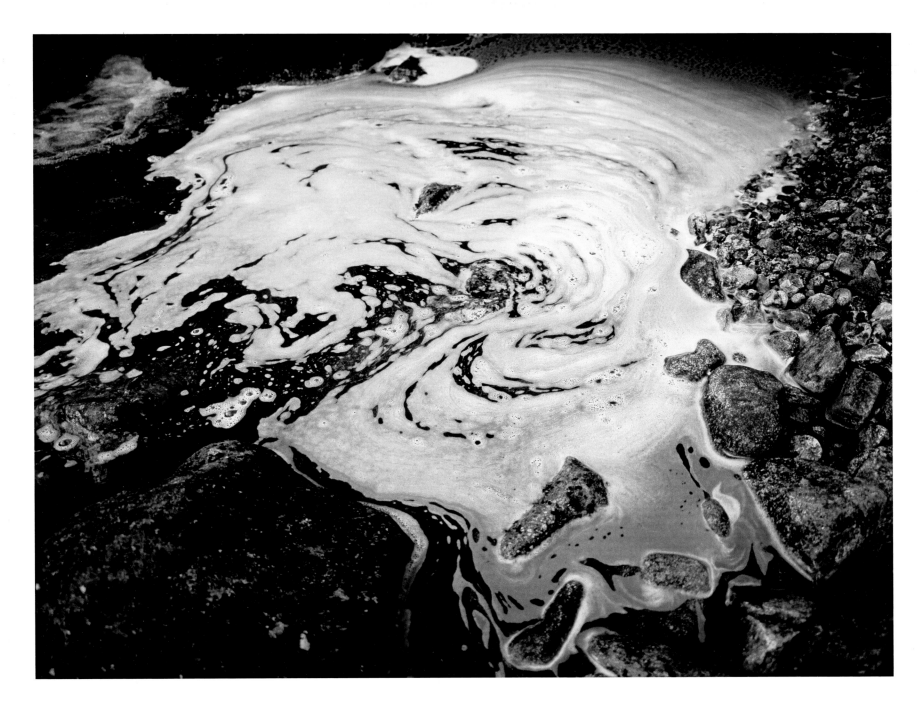

87
Glenealo River

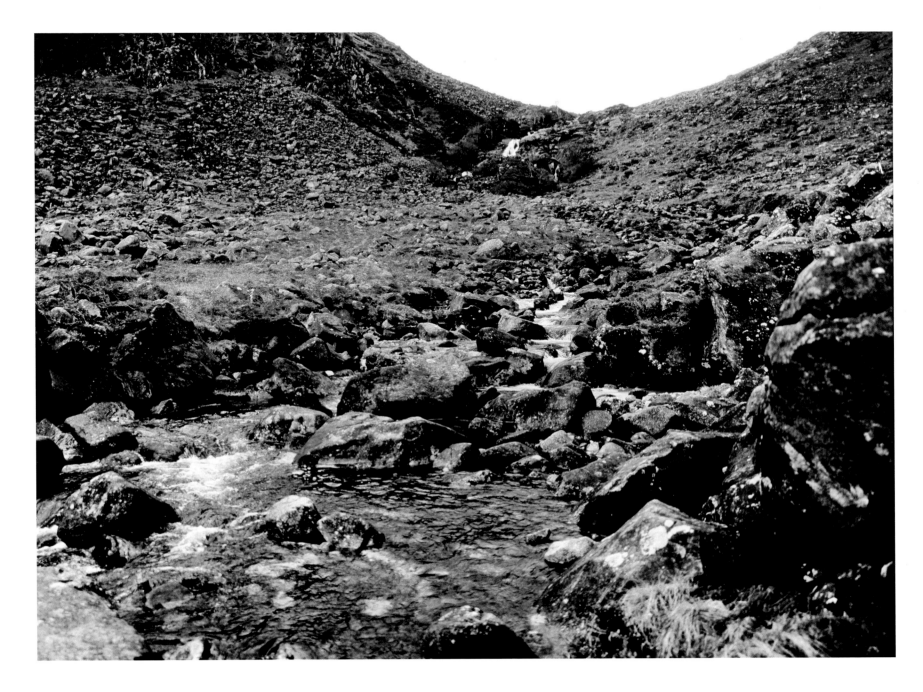

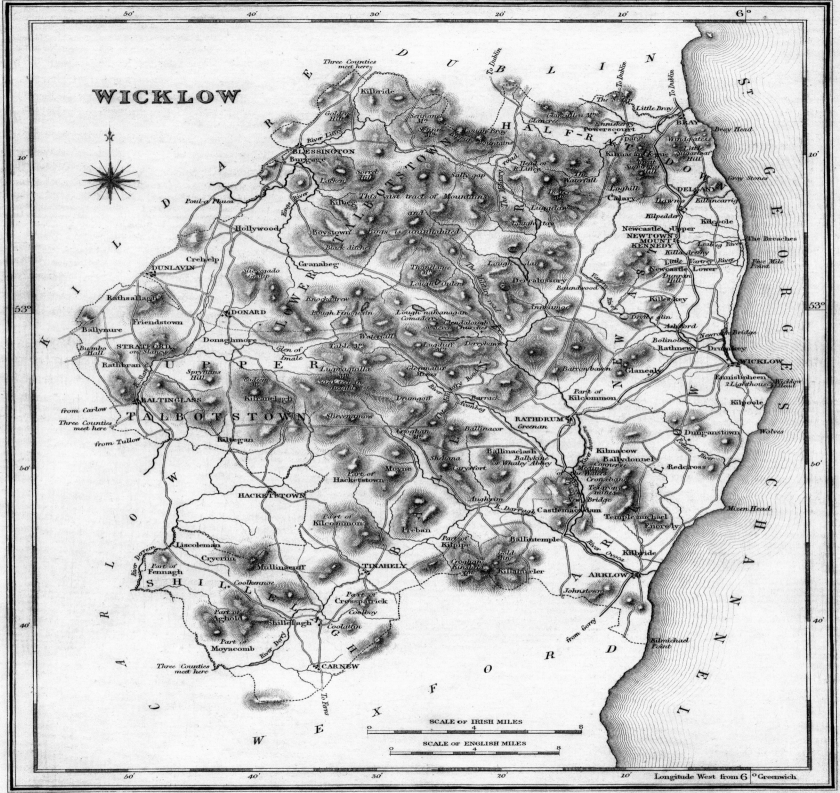

# WICKLOW

SCALE of IRISH MILES

SCALE of ENGLISH MILES

Drawn by S. Lewis, Jun.ʳ

DRAWN AND ENGRAVED FOR LEWIS' TOPOGRAPHICAL DICTIONARY.

Engraved by I. Dower Pentonville London.

Longitude West from 6°·Greenwich

Place
Names

## Wicklow-Cill Mhantáin
*Contae Chill Mhantáin*

The English name "Wicklow" means the water-meadow of the Vikings. The Irish name "Cill Mhantáin" means the church of Mantán.
The lore surrounding the name states that when St. Patrick and his followers arrived in Wicklow the local people were not happy to see them and threw stones at the monks. One of the monks had his teeth knocked out and was thereafter called Mantán, a derivative of mantachán meaning a toothless person, and this monk was later said to have established a church in Wicklow. However, as no examples of the name Mantachán are attested, this is clearly an example of folk-etymology, or the creation of lore to explain the origins of a placename.

## Coolgarrow mountain
*An Chúil Gharbh*

The word cúil in placenames means "corner" or "nook." Literally "the rough corner."

## Sallygap
*Bearna Bhealach Sailearnáin*

Often mistakenly believed to derive from "Saddle Gap" because of the shape of the hills in the area. A 1655 entry in the Civil Survey, however, writes "Barneballaghsilurnan." The last element appears to contain the word sailearnán referring to a wood of willows or sallies thus the gap of the way/road of the sally wood.

## Brockagh mountain
*Sliabh na Brocaí*

The townland of the rock. It is suggested that it is named from the rocky headland at Jack's Hole .

## Cloghoge
*Clochóg*

Clochóg means stony patch, or place with stone structure

## Lugalla [recte Luggala]
*Log an Lá*

Luggala has been explained as deriving from Log a' Lágha, the hollow of the hill (or ridge) (Joyce, Irish Names of Places Vol. I, 391). However, as there are no attested examples of lagh meaning hill this must remain doubtful. On the other hand, one could suggest that the final element derives from latha > lá "of mud", a genitive singular form of Old Irish loth/lath (see Dictionary of Irish Language)

## Brittas Bay
*Cuan an Bhriotáis*

"Brittas" derives from the Anglo-Norman bretasse, meaning a temporary wooden breastwork. It is a reasonably common element in Irish placenames and there are three examples of the placename Brittas in county Wicklow.

## Glenmacnass
*Gleann Log an Easa*

The glen of the hollow of the waterfall.

## Scarr
*Scor*

Rock pinnacle.

## Annamoe
*Áth na mBó*

The ford of the cows.

## Devils Glen [recte Devil's Glen]
*An Gleann Mór*

The English name, Devil's Glen, appears to be a late creation from the 18th century. The earlier name for this may have been Portdarge, deriving from (An) Port Dearg, "(The) red embankment": "Portdarg… Portdarge… Portdoribeg…seems to have been the name of the Devil's Glen behind Glenmore House" . The whole glen seems to have been called "Glanmore" which derives from (An) Gleann Mór "(The) big glen."

## Nun's Cross [recte Nunscross]

"Nunn was a family name in Wicklow and Wexford in the 18th century, and this name probably means Nunn's cross-roads. It is likely that the name gave rise to the local story that a skeleton found here was that of a nun who had been immured in the wall". The surname Nunn seems to have arrived in Ireland with the Cromwellians.

## Glenmalure

*Gleann Molúra*

The glen of Molúra.

"Molúra" is probably a personal name.

## Rathnew

*Ráth Naoi*

"Ráth" meaning fort.

"Naoi" is probably a personal name.

## Glendalough

*Gleann Dá Loch*

The glen of the two lakes.

## Poulinass

*Poll an Easa*

The pool of the waterfall.

## Tomriland

*Tom Réileáin*

The element réileán, "level space" is found in the place-name Ryland in Wexford, and Tomriland could undoubtedly reflect derivation from Tom Réileáin. The anglicised element "tom" can represent Irish tom, "bush, clump, tuft" or tuaim, "tumulus, mound."

## River Liffey

*An Life*

An Life is well attested in Irish literature as the Irish name of the river, but the meaning of the name is unclear.

**Lough Dan**
*Loch Deán*
The meaning is unclear.

**Lough Tay**
*Loch Té*
Té, "hot" is found in Old Irish but this is hardly what is referred to in Loch Té! Téa is also found as the name of the mythical eponym of Tara in Irish tradition and it is possibly the second element.

**Inchavore river**
*An Inse Mhór*
Inse: island or river meadow. Mór: big.

**Kanturk**
*Ceann Toirc*
The wild boar's peak .

**Glenealo River**
*Abhainn Ghleann Abhlach*
Glenealo: The glen abounding in apple trees.

**Bonagrew Little**
*An Bhánóg Rua*
Explained by John O'Donovan as Bun na gCrodh, "bottom of the cattle folds," in the Ordnance Survey (OS) namebooks (1839), but the occurrence of "Red Park" written on the OS 6" map (1839) sways the evidence towards derivation from Bánóg Rua, from which "Red Park" could be translated.

This information was provided by the Place names commission and from Place Names of County Wicklow by Liam Price.

Acknowledgements

Garech de Brún, Owen O'Gorman, Justin Evers, Suzanne Duggan Evers, Elizabeth Evers, The Power Family, Walter Pfeiffer, Christopher Stacy from Footfalls, Silvia Crompton, Stuart Bradfield, Susanna Costello, Carol Boland, Wicklow Hire, Alan Spellman at GMS, André Gardiner at GMS, Heidi and Michael Corr, Jenny Wilkinson, Hugh Glynn, Mike Bunn, Trevor Hart, Simon Burch, The Gunn Family, Brian Daly, Rapideye London, APUG, Aiden Grennelle ,PCI, Eamon de Buitlear ,Ed Dunne at Inspirational Arts, Fintan Kennedy, Marcus Fitzgerald, Diane Neal, Patrick Brangan, Sadia Brangan, Davin Bogan, Dina Bogan, The O'Brien Family, Rebecca Morgan, Dan and Jessie, Paul Ferguson at The Map Library Trinity College Dublin, Antony Farrell at Lilliuput Press, Timothy Tate, Gary McDarby and Slí na Firinne, Angela Fitzpatrick, Tom Galvin and Wicklow County Library

Particular thanks to
Susie O'Brien, Patricia Evers and Vince Murphy

Imprint

Produced by Huxley Press

Designed by Aiden Grennelle

Printed by EBS- Editoriale Bortolazzi Stei
Verona, Italy

ISBN
978-0-9560637-0-0

Published in Ireland BY
Huxley Press
The Gate Lodge
Glendalough Estate
Annamoe
County Wicklow

www.wicklowphotographs.com

Peter Evers was born in 1973 in Dublin.
He lives in Annamoe, County Wicklow.

Prints of the work featured
in this book are available to order at
www.wicklowphotographs.com